Remembering
Virginia

Emily J. and John S. Salmon

TURNER
PUBLISHING COMPANY

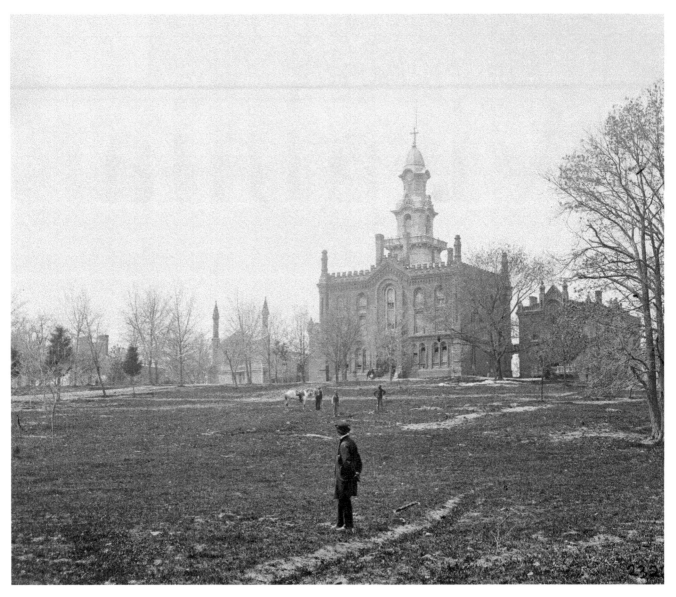

The Protestant Episcopal Theological Seminary in Virginia, or Virginia Theological Seminary, was established in 1823 and located on this site overlooking Alexandria in 1827. Over the next few decades, several outstanding Victorian buildings were constructed, including Aspinwall Hall, completed in 1859 and shown here not long afterward. Norris G. Starkweather, a Baltimore architect, designed it in a unique blend of Italianate and Romanesque styles. It still stands, changed very little from its Civil War–era appearance.

Remembering
Virginia

Turner Publishing Company
4507 Charlotte Avenue • Suite 100
Nashville, Tennessee 37209
(615) 255-2665

Remembering Virginia

www.turnerpublishing.com

Library of Congress Control Number: 2010926215

ISBN: 978-1-59652-691-4

Printed in the United States of America

ISBN: 978-1-68336-902-8 (pbk)

10 11 12 13 14 15 16—0 9 8 7 6 5 4 3 2 1

CONTENTS

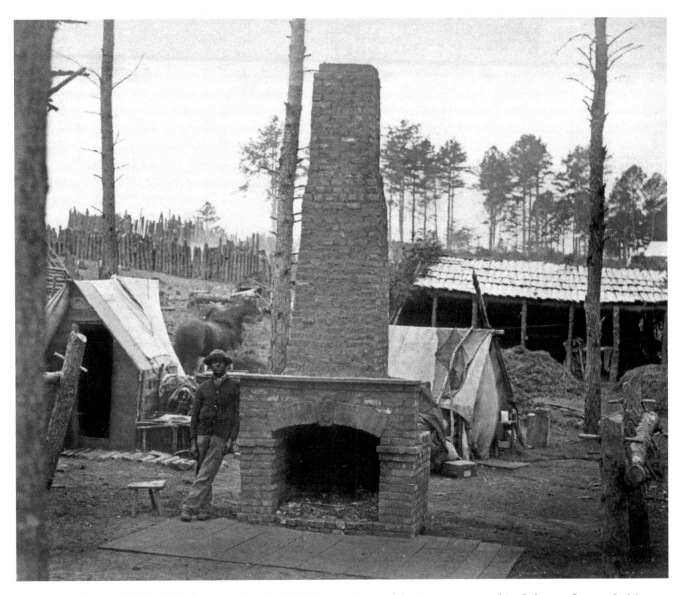

During the winter of 1863–1864, the approximately 100,000-man Army of the Potomac camped in Culpeper County. In May 1864, when the Union forces began their movement south toward Richmond, they left behind a variety of well-constructed and fairly comfortable winter quarters. These remnants were photographed as the army left Brandy Station, a stop on the Orange and Alexandria Railroad in Culpeper County.

Acknowledgments

This volume, *Remembering Virginia,* is the result of the cooperation and efforts of many individuals and organizations. It is with great thanks that we acknowledge the valuable contribution of the following for their generous support:

Eastern Regional Coal Archives, Craft Memorial Library, Bluefield, West Virginia
Library of Congress
Library of Virginia
Tazewell County Public Library
Waynesboro Public Library

We would also like to thank Dale Neighbors of the Library of Virginia for his valuable contribution and assistance in making this work possible.

PREFACE

From the founding of the first English colony in the New World at Jamestown in Virginia in 1607 until the Declaration of Independence in 1776 was almost 170 years. From that date until the beginning of the American Civil War in 1861 was an additional 85 years—more than two and a half centuries total since Jamestown was established. Nearly a century and a half has elapsed since the beginning of the Civil War. As distant as these milestones of history may seem today, Virginians are fortunate to be able to look around and see the physical evidence of great events, people, and places everywhere in the Old Dominion.

Just a few years ago, archaeologist William Kelso made an important discovery at Jamestown: James Fort, believed to have eroded into the James River, was found to be largely intact. A vast number of artifacts have been unearthed there, and an "archaearium" was constructed to house them and tell the fascinating story of the colony's early years. Visitors to Jamestown can see the artifacts and watch the ongoing excavation of James Fort.

The oldest extant structure of English origin in Virginia, a remnant of an earthen fort that Captain John Smith ordered built in 1608, is still visible at Smith's Fort Plantation in Surry County. At Colonial Williamsburg, the original and reconstructed buildings remind us of the Revolutionary era. Throughout Virginia, Civil War battlefields serve as monuments to those who fought and died there and also as major tourist attractions.

Remembering Virginia contains images of many of these important places and of others that emerged as the state developed. The book is divided into four eras. The first part covers the period from the Civil War to 1909, a time of tremendous conflict and change in the battle-torn state. The second section spans the next two decades, a period of considerable optimism as coal, shipping, and other industries grew, and new modes of transportation took hold. Part Three covers the years 1930 to 1945, when Virginians struggled through the Great Depression and signed on for the war effort, as did Americans everywhere. The fourth section continues the story from 1946 to the 1970s, a postwar era marked by increased prosperity, growth in tourism throughout Virginia, and the impact of the civil rights movement.

In each of these sections the effort has been made to capture various aspects of life through the selection of photographs. People, commerce, transportation, infrastructure, religious institutions, and educational institutions have been included to provide a broad perspective. With the exception of cropping images where needed and touching up imperfections that have accrued over time, no changes have been made to the photographs in this volume. The caliber and clarity of many photographs are limited by the technology of the day and the ability of the photographer at the time they were made.

Most of the images in *Remembering Virginia* depict places one can visit today. Many sites, such as Monticello and the Skyline Drive, are well known and immensely popular. Other places may be less famous but are no less interesting. In 2007, as Virginia commemorated the 400th anniversary of the establishment of Jamestown, visitors came from around the world to attend events and observances and to see the site of the first colony. Another major commemoration, the Virginia Sesquicentennial of the American Civil War, will begin in 2009 and will end in 2015 on April 9 at Appomattox Court House, as did the war in Virginia. The Virginia Civil War Trails program links more than 400 sites with colorful markers along the state's highways, including places depicted in this book such as Brandy Station, City Point, and Richmond. For driving tour brochures, call 1-888-CIVIL WAR or visit the Trails Web site, which has downloadable maps, at www. civilwartrails.org. For information about the Sesquicentennial, visit the Web site at www.virginiacivilwar.org. The state has a fascinating story to tell, of people, places, and events, through its historic sites, architectural masterpieces, museums, roadside markers, and landscapes, as well as through photographs such as these.

But don't wait for a commemoration to come and see what Virginia has to offer!

—*Emily J. and John S. Salmon*

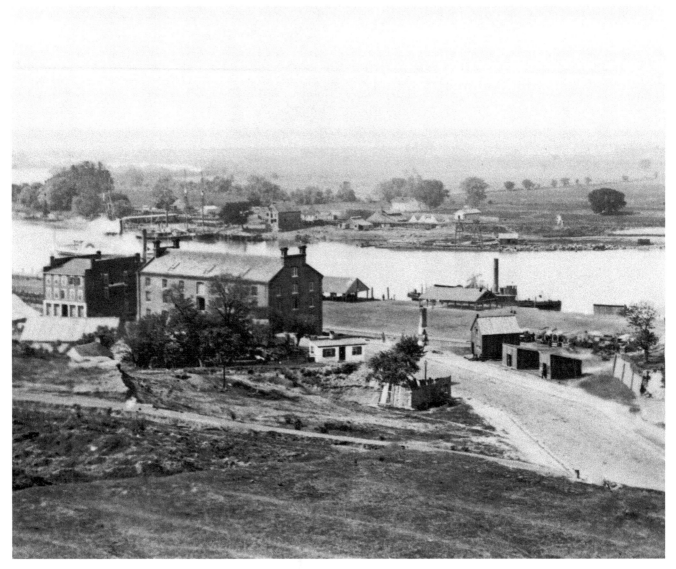

The similarity between this view of the James River, and the view of the Thames River in England at the town of Richmond upon Thames, is believed to have inspired William Byrd II, founder of Virginia's Richmond in 1738, to give the new town that name. The buildings and wharves in this April 1865 photograph constitute Rocketts Landing, for many years the port of Richmond, located just downstream from the city. Before the Civil War, Richmond was a center of the domestic slave trade, and many hundreds of thousands of enslaved men, women, and children boarded vessels at Rocketts for the journey to Deep South plantations. Today a visitor can see the identical view from Chimborazo Park in Richmond.

FROM WAR TO A NEW CENTURY

(1861–1909)

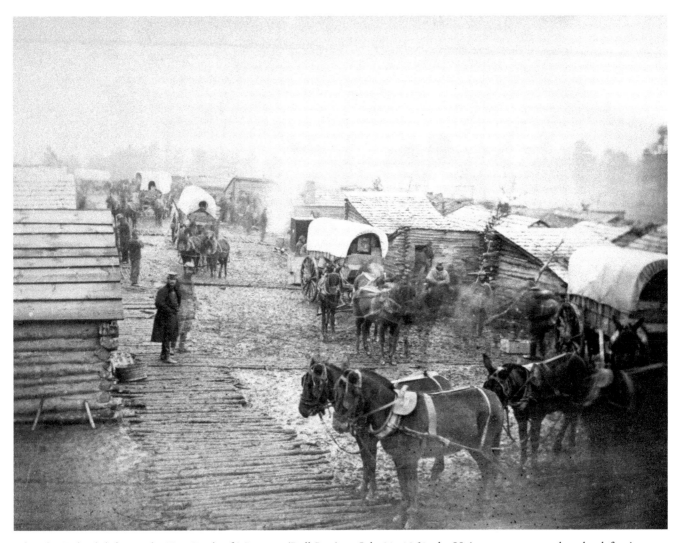

After the Federal defeat at the First Battle of Manassas (Bull Run) on July 21, 1861, the Union army retreated to the defensive works under construction around Washington, D.C. There the army remained throughout most of the autumn and winter, refitting and training, while President Abraham Lincoln chafed at the inaction. This image, taken that winter at a camp in Virginia near Centreville, shows soldiers' huts, horses, and wagons.

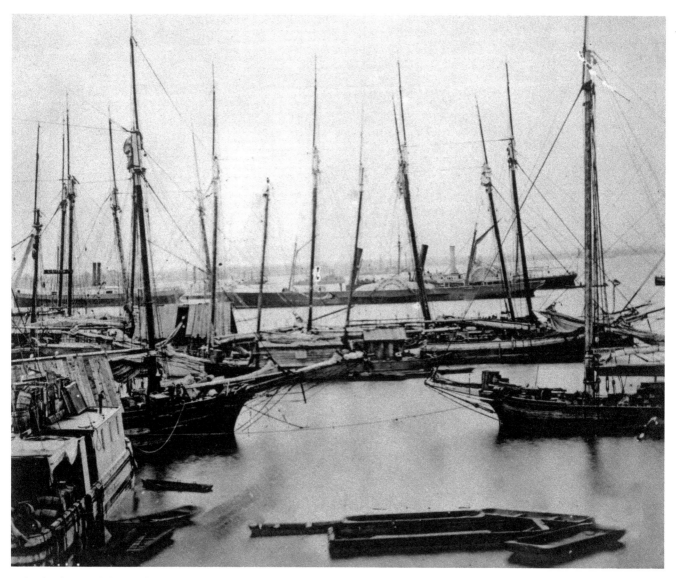

In the third year of the Civil War, after Lincoln had summoned Lieutenant General Ulysses S. Grant from the West to command all of the Union armies in the field, Grant initiated several simultaneous attacks in the Confederacy early in May 1864. After a series of ferocious battles in Virginia between the Army of the Potomac, commanded by Major General George G. Meade, and Confederate General Robert E. Lee's Army of Northern Virginia, Grant and Meade succeeded in maneuvering Lee into defensive positions to protect Richmond and the vital rail and supply center at Petersburg south of the Confederate capital. The Federals turned the village of City Point (present-day Hopewell), located east of Petersburg, into a vast supply center, as this photograph shows.

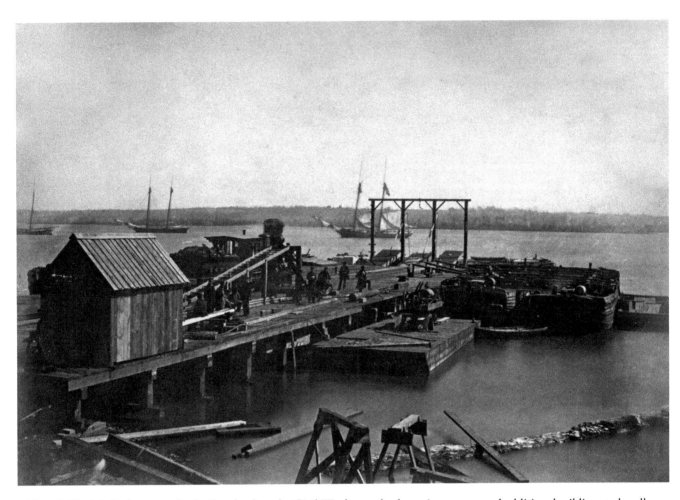

Although Virginia had a network of railroads when the Civil War began, both armies constructed additional rail lines to handle the enormous quantities of food and other supplies that the troops needed. Each side also moved men by rail when feasible. This image, taken about 1862–1863, shows a United States Military Railroad wharf in Alexandria.

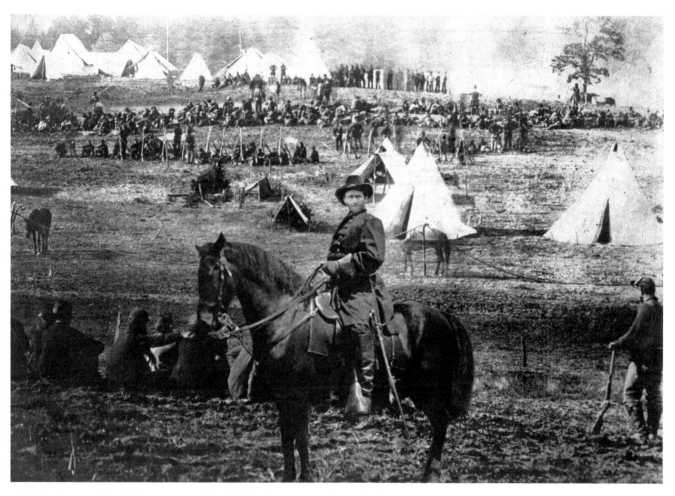

This photograph, which appears to show Union Lieutenant General Ulysses S. Grant at City Point, was actually created in 1902 from several other photographs. Grant's head is from an image taken in 1864 at his Cold Harbor headquarters, the body and horse are of Major General Alexander M. McCook and his mount, and the men in the background are actually Confederate prisoners captured during the Battle of Fisher's Hill in the Shenandoah Valley on September 22, 1864.

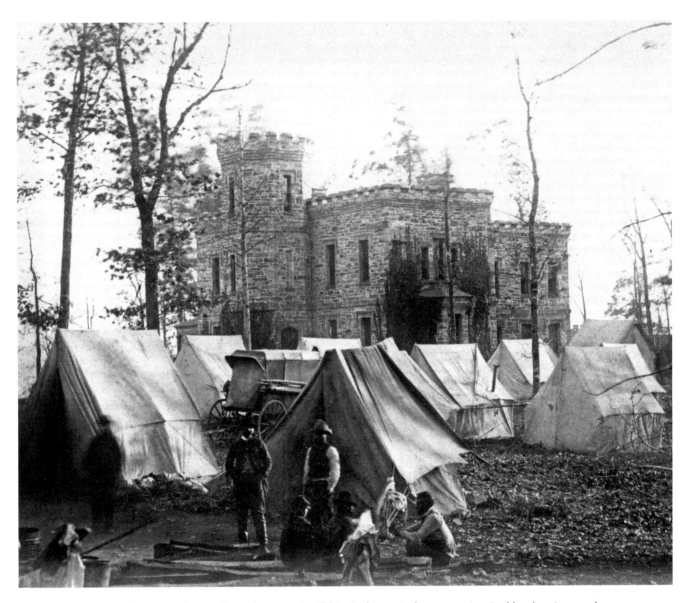

Federal troops camped in November 1863 on the grounds of this Gothic-revival structure inspired by the nineteenth-century novels of Sir Walter Scott. Dr. James H. Murray, of Maryland, purchased a large farm in Fauquier County near Auburn in 1856, and between 1857 and 1860 constructed the house, designed by Baltimore architect Edmund George Lind. Murray named it Melrose, for Melrose Abbey in Scotland. Happily, the house survived the war and today is a private residence listed on the National Register of Historic Places. It served as the inspiration for Mary Roberts Rinehart's 1908 mystery *The Circular Staircase*.

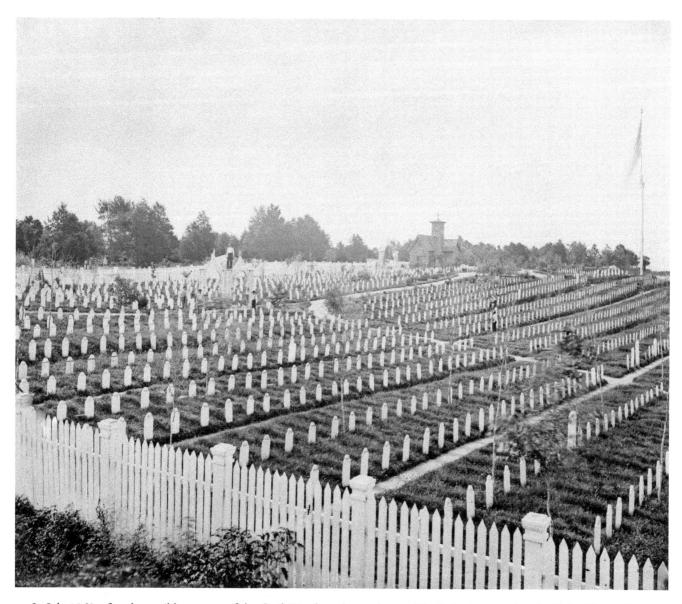

In July 1862, after the terrible carnage of the Civil War drove home the need for Federal cemeteries, the United States Congress authorized the president to purchase land to bury "soldiers who shall have died in the service of the country." Fourteen national cemeteries were established that year, including this one in Alexandria. After the war, cemeteries for the Confederate dead were created in the Southern states. The actual number of war dead—Union and Confederate—is not known, but the figure of about 630,000 is generally accepted as a close estimate.

During the siege of Petersburg, which lasted from June 1864 until April 1865, Northern photographers descended on the Union lines to capture scenes for the newspapers, magazines, and galleries of New York and other cities. Some photographers served the Union army, such as these cameramen attached to the Engineer Corps before Petersburg in March 1865. One of the duties of military cameramen was to copy maps for use by senior officers, using photosensitive paper.

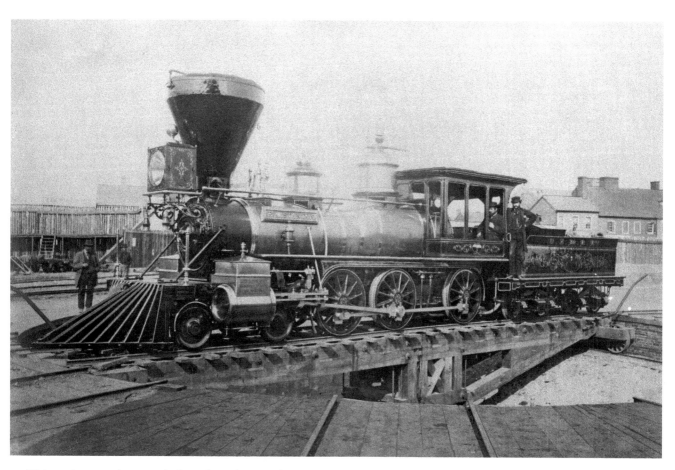

This engine was photographed in Alexandria in July 1864. It was named for United States Secretary of War Edwin M. Stanton.

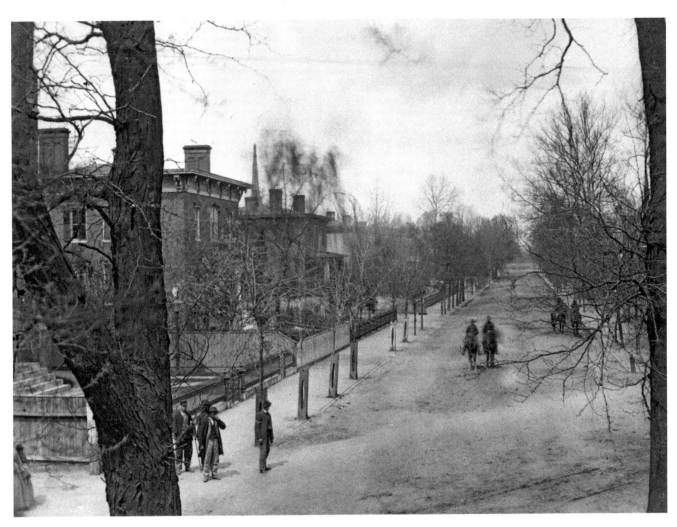

In this view of Market Street in Petersburg, looking north from Halifax Street, the building at left behind the forked tree is the Wallace House, which still stands. There, on the morning of April 3, 1865, a short time before this picture was made, President Abraham Lincoln and Lieutenant General Ulysses S. Grant met for the last time. Although the house's owner invited both men inside, Grant, who as usual was smoking a cigar, declined. The president and the general sat on the front porch and discussed Grant's plan for pursuing General Robert E. Lee's Army of Northern Virginia, which had just evacuated Petersburg and was marching west. The men then parted, never to see each other again.

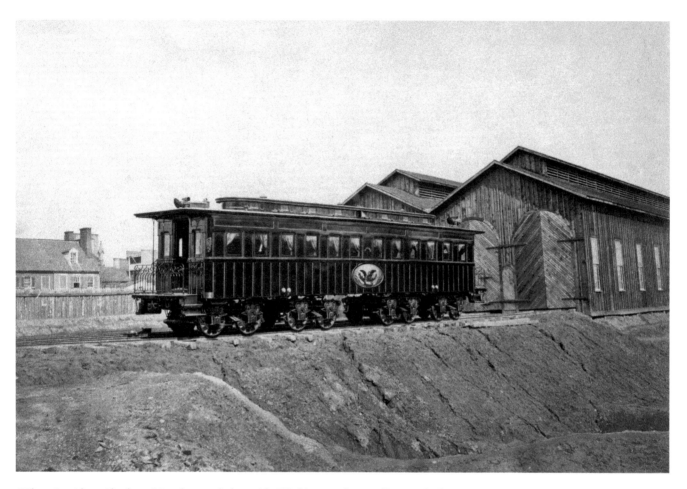

When President Abraham Lincoln traveled outside Washington, he usually went by boat or train. Andrew J. Russell photographed Lincoln's elaborate railroad car in January 1865; Lincoln never used it while he was alive. Following his assassination, however, his coffin was placed in this car and transported across the country to Springfield, Illinois, where he was buried.

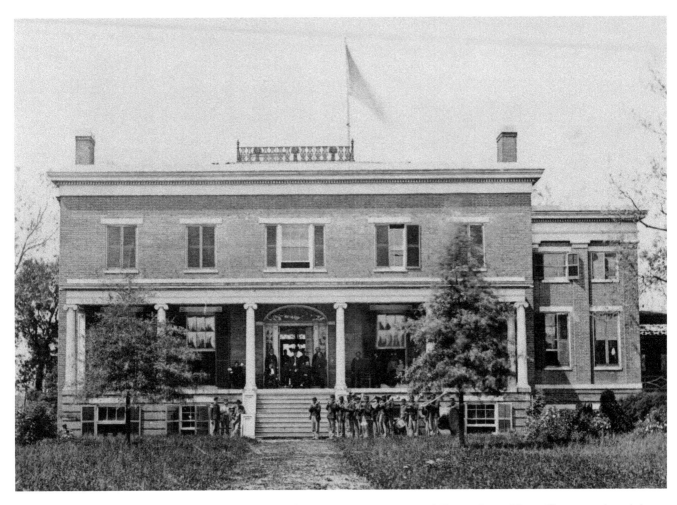

After the Federal army captured Petersburg early in April 1865, Union major general George Lucas Hartsuff commandeered the Centre Hill mansion for his headquarters. Completed in 1823, Centre Hill was one of the largest and most richly appointed houses in Virginia. Hartsuff entertained President Lincoln there on April 7. A regimental band is posed in front of the house in this April 1865 photograph.

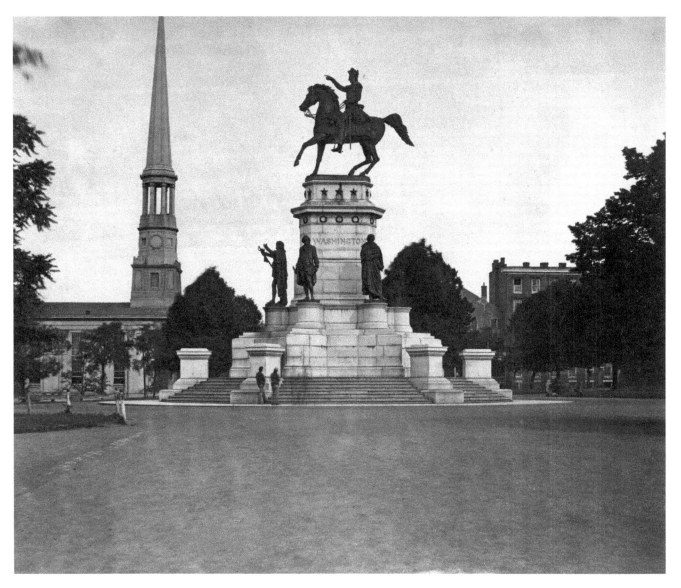

Taken April 12, 1865—nine days after the capture of the Confederate capital, and three days after General Robert E. Lee surrendered the Army of Northern Virginia at Appomattox Court House—this image shows the bronze equestrian statue of George Washington at the western end of Capitol Square in Richmond. Thomas Crawford, a Philadelphia artist, sculptured the statue, which was cast in Europe and unveiled on February 22, 1858. The parade of statues of famous Virginians around the base was not completed until August 1868.

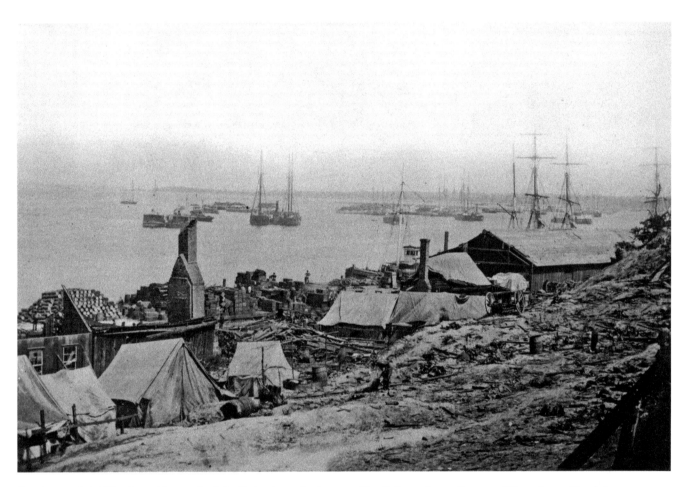

On August 9, 1864, a huge blast rocked the Federal supply depot at City Point, a few miles east of Petersburg. Confederate agents John Maxwell and R. K. Dillard infiltrated the Union ammunition barge *J. E. Kendrick* about 10:00 A.M. and planted a bomb with a timer. It exploded an hour and 40 minutes later, flattening buildings and flinging ammunition, pieces of equipment, and human body parts for hundreds of yards, resulting in at least 46 killed and 126 injured. A portion of the aftermath is seen here.

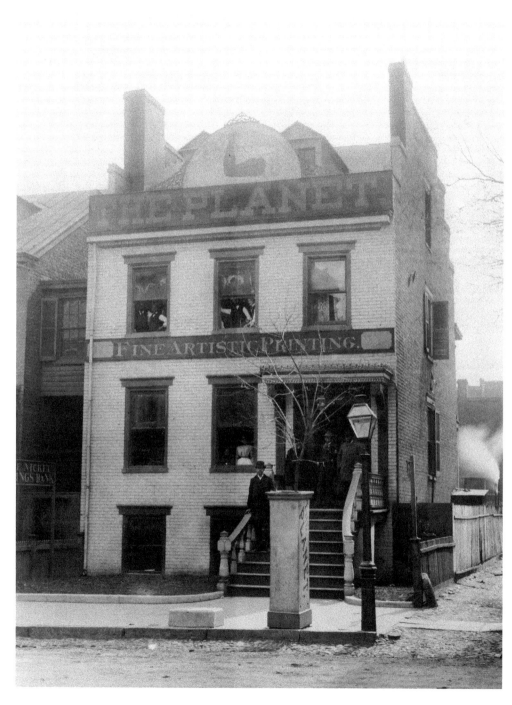

John R. Mitchell, Jr., edited the *Planet,* Richmond's pioneering black newspaper, from 1884 until his death in 1929. The newspaper's offices were first located at 814 East Broad Street, and by 1899 at 311 North Fourth Street, where this picture was taken. The *Planet* became one of the most important African American newspapers in the country under Mitchell, crusading for civil rights and against lynching and other forms of oppression.

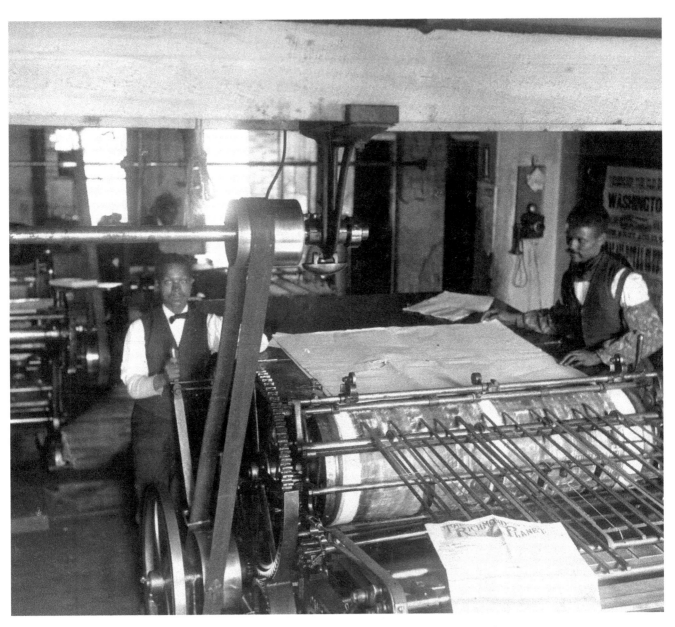

In the press room of the *Planet,* another issue is about to be printed. The photograph was taken about 1899.

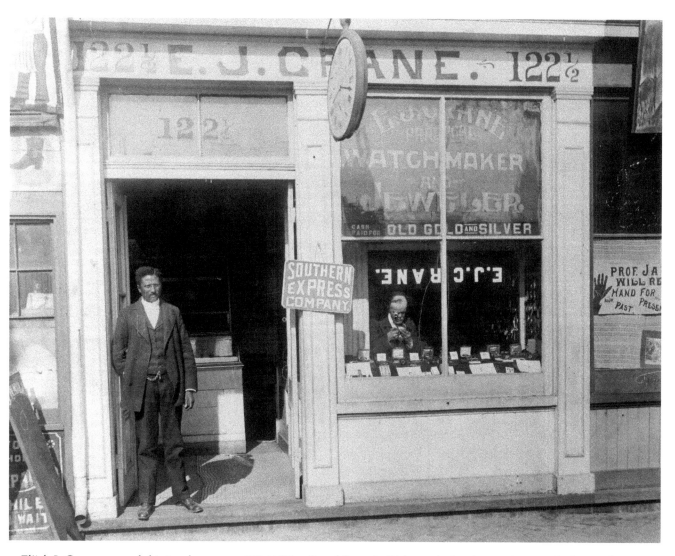

Elijah J. Crane operated this jewelry store at 122 ½ West Broad Street in Richmond when it was photographed around 1899. Its clientele drew largely from the predominantly African American neighborhood of Jackson Ward nearby.

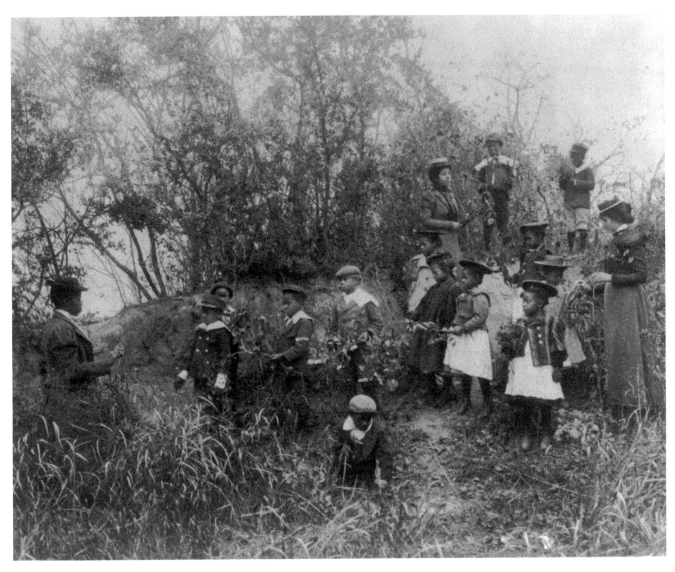

Hampton Institute offered not only a college curriculum, but it also had a children's school, the Whittier Primary School. In December 1899, Frances Benjamin Johnston photographed these children on a field trip as they studied plants. The Whittier School, named for New England poet John Greenleaf Whittier and financed by Elizabeth City County, was established in 1887. It closed about 1930.

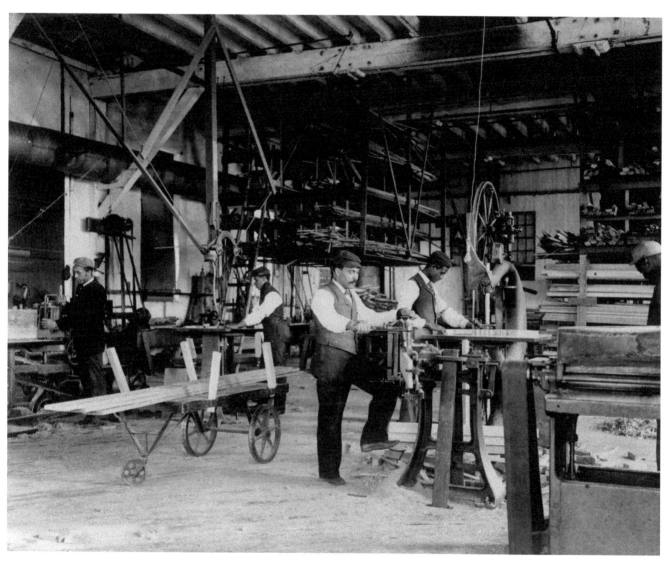

Continuing her 1899 Hampton Institute series, Frances Benjamin Johnston photographed this woodworking class.

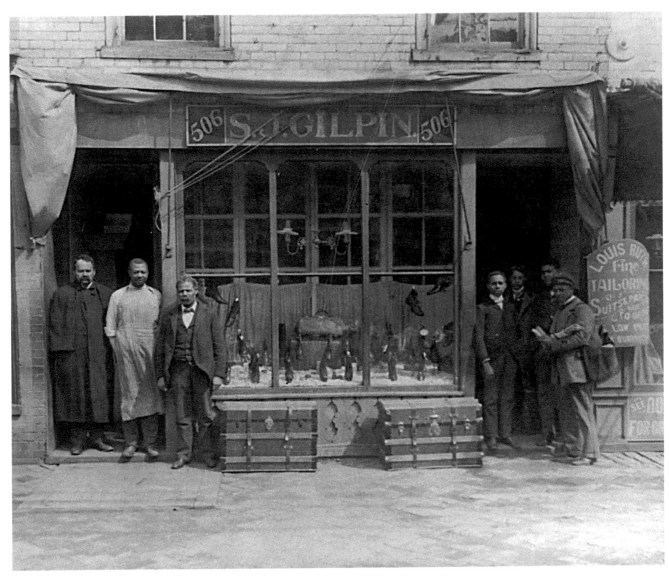

Located just south of Jackson Ward, a predominantly African American neighborhood in Richmond, S. J. Gilpin's shoe store was one of many small businesses operated by blacks in the area. St. James Gilpin owned the store, located at 506 West Broad Street, when it was photographed about 1899.

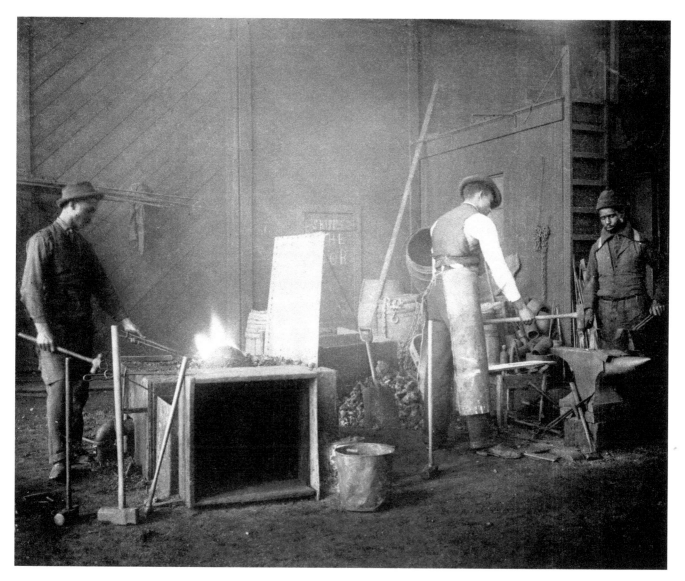

This picture shows workers in the Newport News Shipbuilding and Dry Dock Company metal shop about 1899. The company was a logical extension of Collis P. Huntington's Chesapeake and Ohio Railroad terminal at Newport News. Huntington envisioned a ship-repair facility at the port, and thus incorporated the Chesapeake Dry Dock and Construction Company in 1886. The dry dock opened three years later, and when increasingly damaged ships arrived for repair, the next step was to add full-scale shipbuilding to the repair facility. The shipyard's name became Newport News Shipbuilding and Dry Dock Company on February 17, 1890.

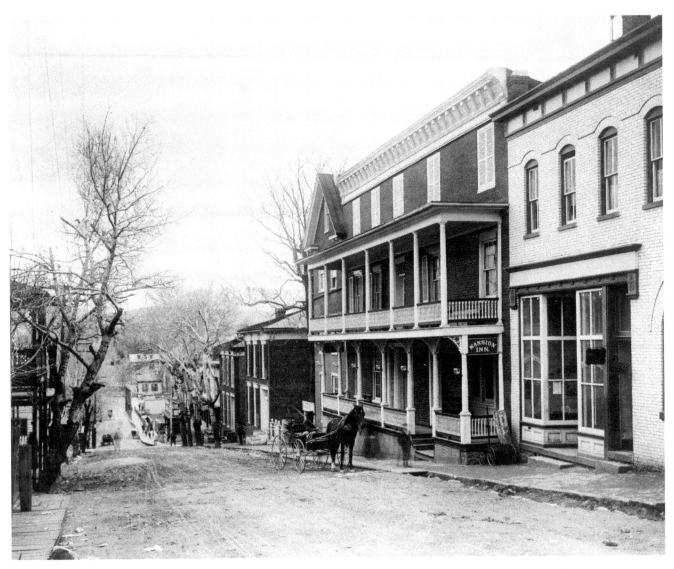

The town of Luray, the Page County seat, is located west of the Blue Ridge Mountains in the Page or Luray Valley, technically separate from the Shenandoah Valley but popularly considered part of it. Discovered in 1878, the Luray Caverns near the town constitute one of the most popular tourist attractions in the area. This photograph of downtown Luray and the Mansion Inn was taken in 1906.

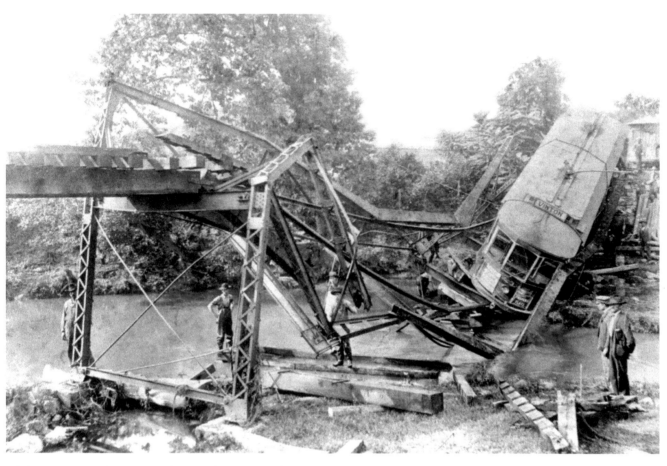

This streetcar crashed into Tinker Creek near Roanoke when the street-railway bridge suddenly collapsed on September 5, 1906. The car was carrying about a hundred passengers en route from Vinton, a suburb, to the city of Roanoke. Charles Cuff was killed instantly, and five others were injured, including Charles Parker, P. B. Lane, Frank Bell, Fred Long, and Mrs. W. D. Prince. Conductor Trout had just started across the bridge after boarding some passengers when it fell; he was credited with keeping the riders from trampling one another as they struggled to escape. The cause of the bridge collapse was not known.

When President Theodore Roosevelt visited Portsmouth in 1906, the city honored him with a parade, shown here passing down Court Street. The next year, as one of the highlights of the Jamestown Ter-Centennial Exposition, Roosevelt sent the Great White Fleet sailing from Hampton Roads on an excursion to the Far East to intimidate Japan, a nation with expansionist ideas. Sixteen battleships, all painted white, steamed away, and then returned to Hampton Roads and another huge celebration on February 23, 1909.

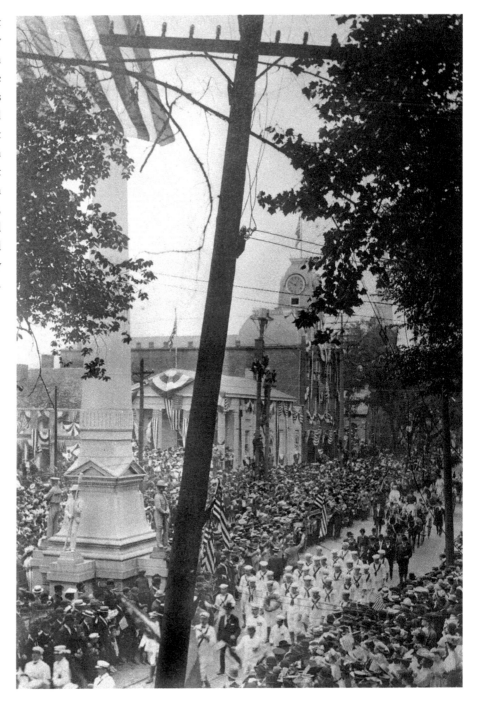

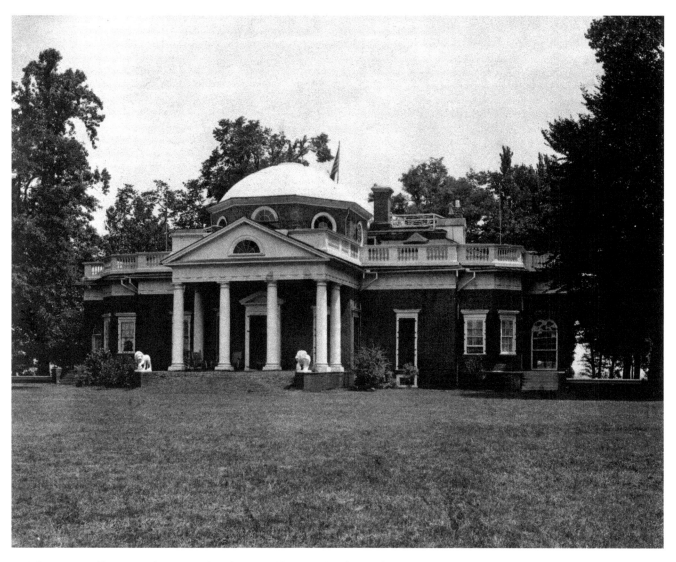

That Monticello survived is a miracle. Thomas Jefferson, who designed it and then spent 40 years building it, died so heavily in debt in 1826 that his heirs had to sell it two years later. Soon, the house and gardens fell into disrepair, but in 1833 United States Navy Lieutenant Uriah Levy, a devoted admirer of Jefferson, bought the estate and began repairing the house and grounds. When Levy died in 1862, he left a convoluted will that his family contested. In 1879, his nephew Jefferson Monroe Levy acquired the property, but by then a careless groundskeeper had allowed the place to fall into a near-ruinous condition. Jefferson Levy, like his uncle, spent a fortune restoring the property; this photograph was taken in 1906. After financial reverses, Levy reluctantly sold the property to the Thomas Jefferson Foundation in 1923 and burst into tears when he signed the papers.

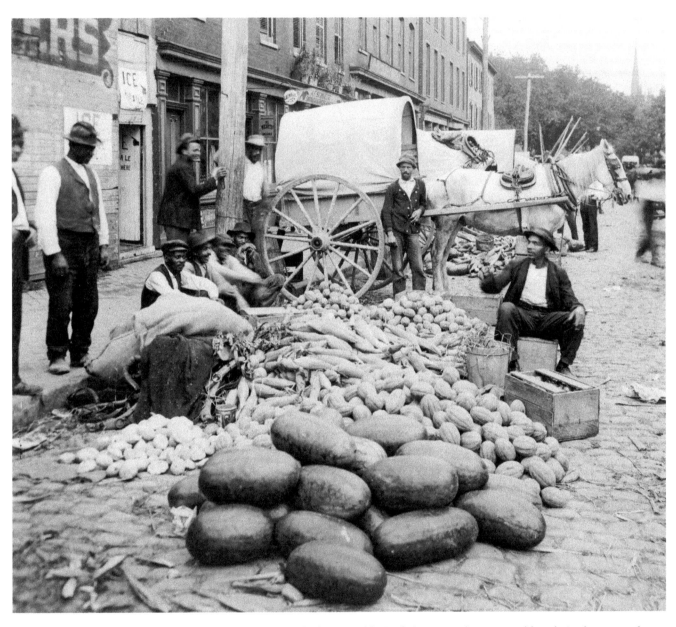

Located on the southern edge of Richmond's Jackson Ward, the venerable Sixth Street Market operated largely in the street when this picture was taken in 1908. The view is west on Marshall Street from the intersection with Sixth Street.

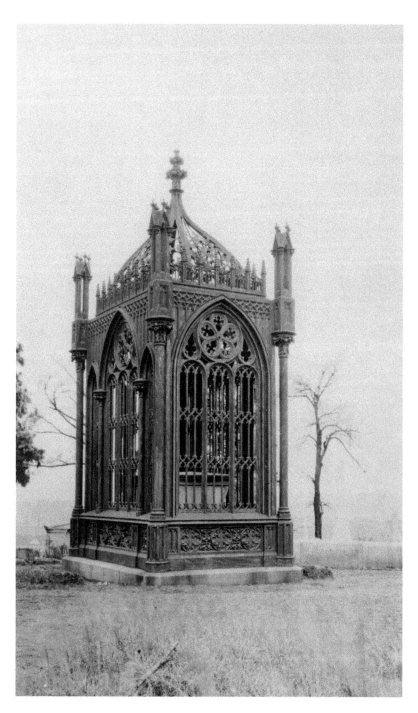

The Gothic Revival–style cast-iron tomb of President James Monroe in Richmond's Hollywood Cemetery was photographed in 1908. It has been a Richmond landmark since 1858, when Monroe's remains were reburied there after removal from New York City, where he had died in 1831. Albert Lybrock, an architect who settled in Richmond in 1852, designed the tomb, which resembles that of Henry VII in Westminster Abbey.

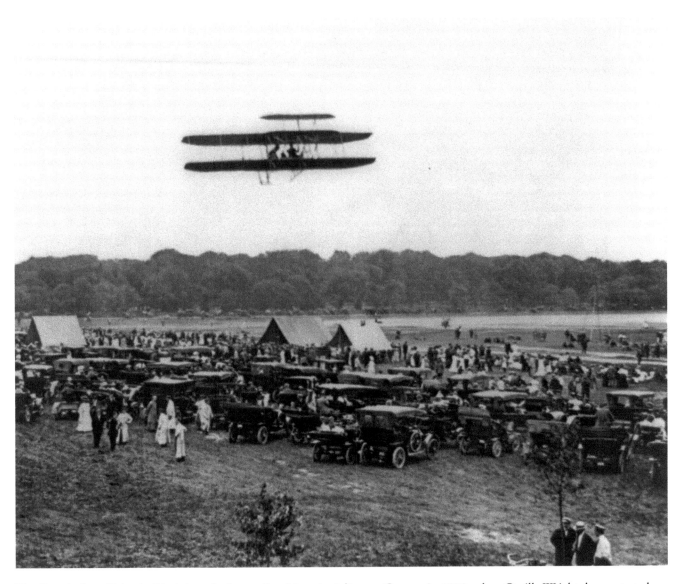

The first airplane flights in Virginia took place at Fort Myer, in Arlington County, in 1908, when Orville Wright demonstrated the capabilities of his heavier-than-air craft. On July 27, 1909, Wright returned to Fort Myer and was photographed as he flew 50 miles at a speed of 40 miles per hour. Wright's passenger was Lieutenant Frank P. Lahm, of the United States Signal Corps. Four days later, the United States Army bought its first aircraft—the plane shown in this picture.

THE ROARING DECADES

(1910–1929)

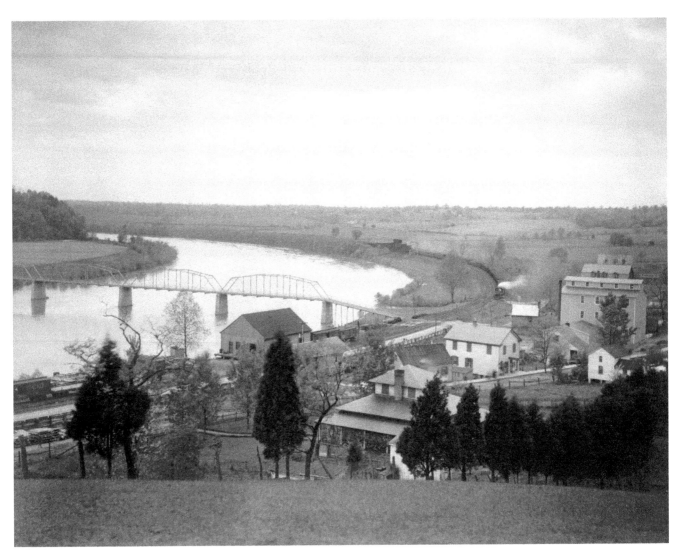

Scottsville, scenically located on a bend of the James River east of the Blue Ridge Mountains in southern Albemarle County, was photographed in 1911 as a train approached. The railroad replaced the James River and Kanawha Canal, a nineteenth-century internal improvement project that the state partly financed, which had helped make Scottsville an important flour market. Much of the infrastructure was destroyed during the Civil War, and for years Scottsville was subject to devastating floods. Now protected from high water, this picturesque town has undergone a renewal in recent decades.

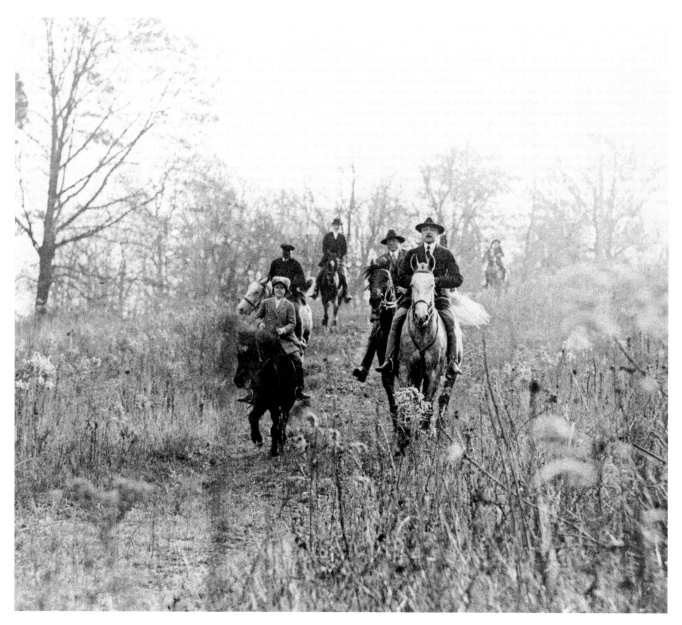

In Virginia, hunting on horseback has long been associated with country gentlemen chasing the red fox—"the unspeakable in pursuit of the inedible," as Oscar Wilde put it. This photograph from between 1910 and 1930 may show such a hunt, with a boy along for the chase on his pony.

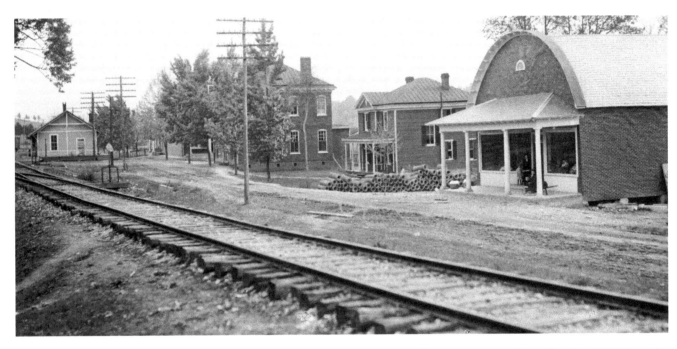

Esmont, a small town located south of Charlottesville and just east of the Blue Ridge Mountains, is shown here in 1910. The train tracks are a spur of the Nelson and Albemarle Railroad, named for the two counties through which it passed. To the left is the train station. The line had shut down by the mid–twentieth century.

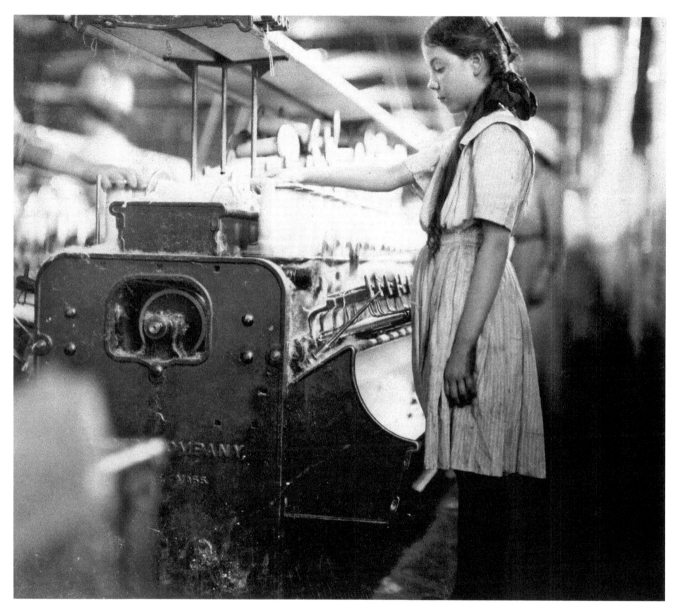

Lewis W. Hine, the investigative photographer for the National Child Labor Committee, captured this image of a young girl working as a spooler at a cotton mill in Roanoke in May 1911. The NCLC, a private nonprofit organization founded in 1903, still actively promotes "the rights, awareness, dignity, well-being and education of children and youth as they relate to work and working."

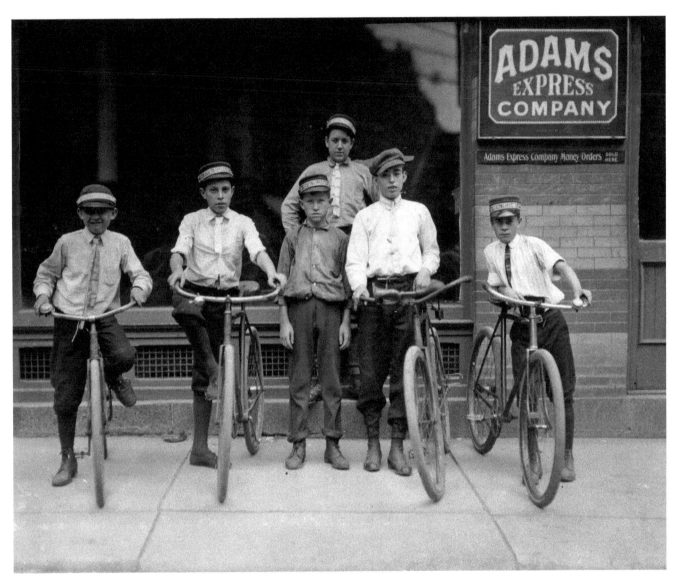

While Lewis Hine made his way around the Hampton Roads area in June 1911, he took this picture of postal messengers in front of the Adams Express Company in Norfolk. Hine wrote: "The Postal boys are not nearly so young, in Norfolk and also in other Virginia cities, as are the Western Union boys." Under the 1913–1921 administration of Virginia-born president Woodrow Wilson, the Progressive Era ushered in child labor laws that curtailed the practice of sending young children to work instead of to school.

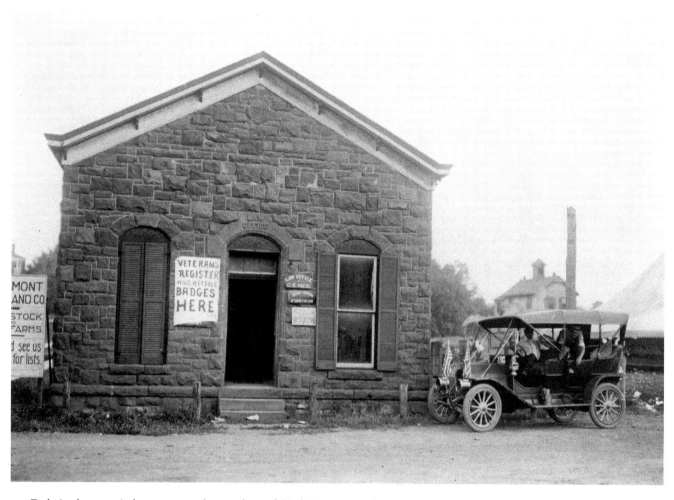

Early in the twentieth century, as the numbers of Civil War veterans began to dwindle rapidly, large-scale reunions were held at important battle sites. Such gatherings reached their climax between 1911 and 1915, during the 50th anniversary of the conflict. On July 21, 1911, 50 years after the First Battle of Manassas, or Bull Run, returning veterans watched a reenactment and then gathered for a "Love Feast of the Blues and Grays" and other ceremonies on the Prince William County courthouse square. The nearby law office shown here served as a registration center for the old soldiers.

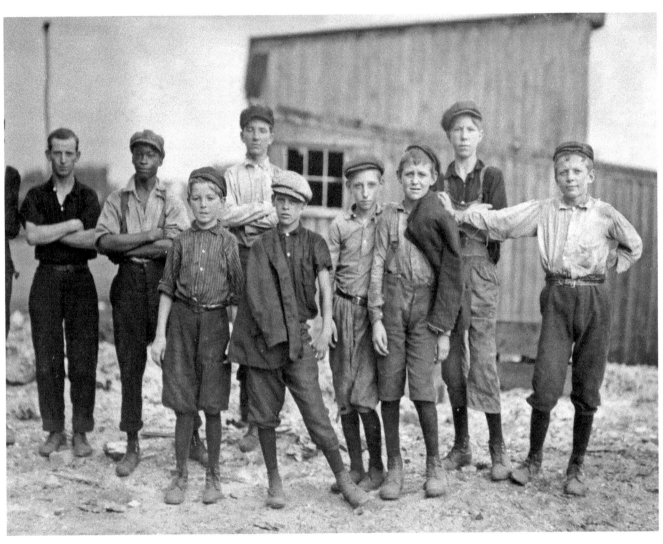

In June 1911, photographer Lewis Hine recorded these boys who worked on the night shift at a glass factory in Alexandria.

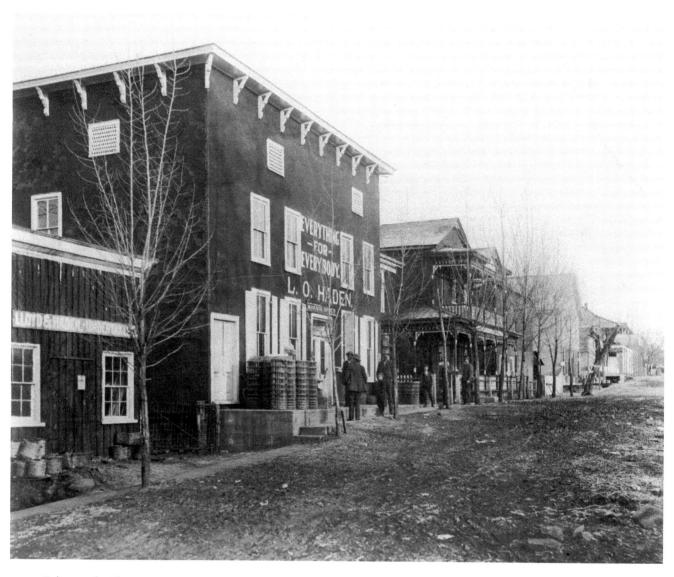

Palmyra, the Fluvanna County seat, is a small town in Virginia's Piedmont, the rolling countryside between the coastal plain and the mountains. Taken in 1912, this picture shows L. O. Haden's general store. If the proprietor could not be all things to all people, at least he had "Everything for Everybody."

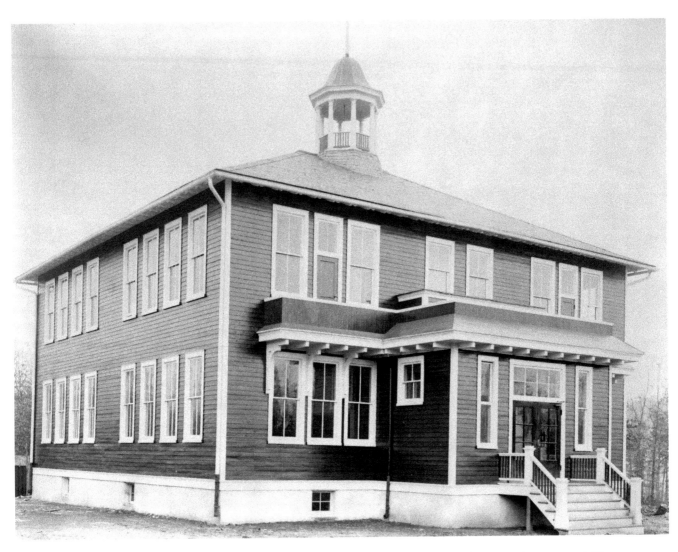

Located in Albemarle County, the Alberene Soapstone Company town included the high school seen here in 1912. The company had been quarrying and finishing soapstone for commercial and domestic uses since about 1870. Not far from Alberene, westward across the Nelson County line at Schuyler, is located one of the company's principal quarries. Earl Hamner, Jr., whose father worked in the soapstone factory, is famous as the creator of the television series *The Waltons*. The Alberene high school was demolished years ago, but the company is still flourishing.

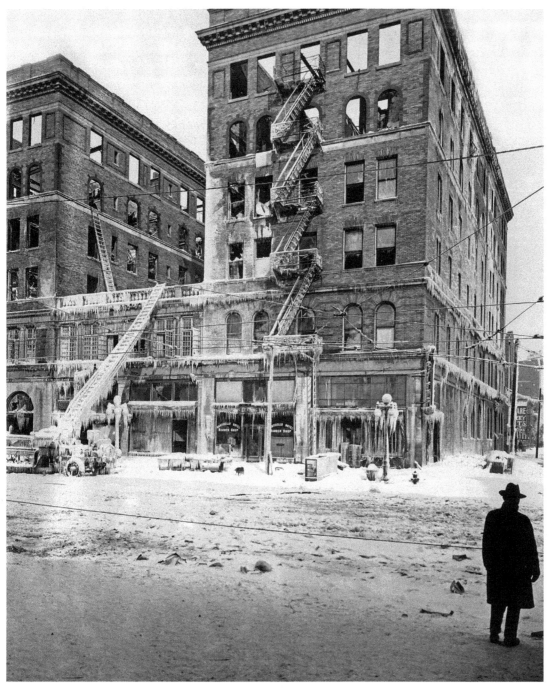

The Monticello Hotel, located on Granby Street at City Hall Avenue in Norfolk, suffered a devastating fire in the freezing cold of New Year's Day 1918. Built between 1896 and 1898 in the Richardsonian Romanesque Revival style, the hotel was restored a year after the fire with two stories added and the latest amenities, including a telephone in each room and electric lighting from the hotel's own power plant. A federal building replaced the Monticello after it was demolished in 1976.

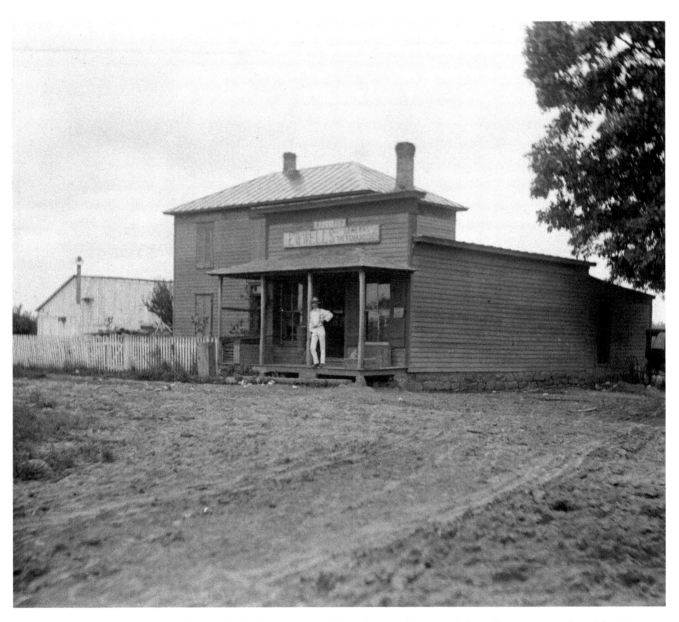

Edward W. Wells's general store, photographed about 1919, was located in rural Prince William County in northern Virginia.

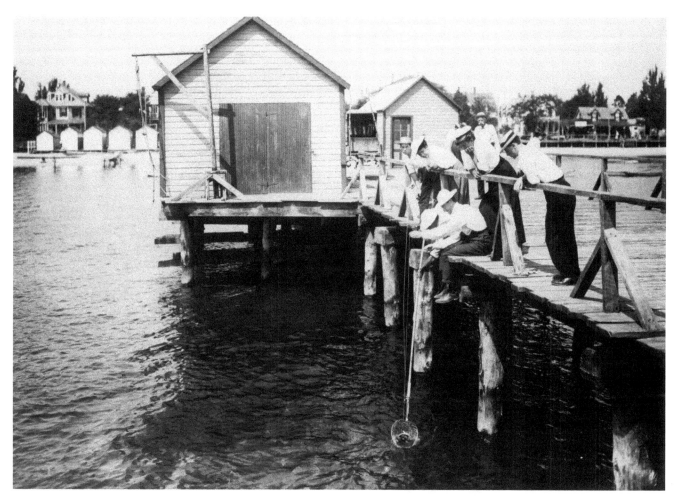

Colonial Beach was established as a bathing and fishing resort in the decades following the Civil War. Located on the south bank of the Potomac River about 50 miles south of Washington and accessible by boat, it became a popular escape from city life. Alexander Graham Bell owned a house there, although it is not known whether he went crabbing from the pier as these men are seen doing probably in the 1920s. Incorporated as a town in 1892, Colonial Beach attracted gambling casinos and prospered for a while, but declined when transportation improvements fueled the growth of true seaside resorts, such as Virginia Beach. The town has experienced a renewal in recent years.

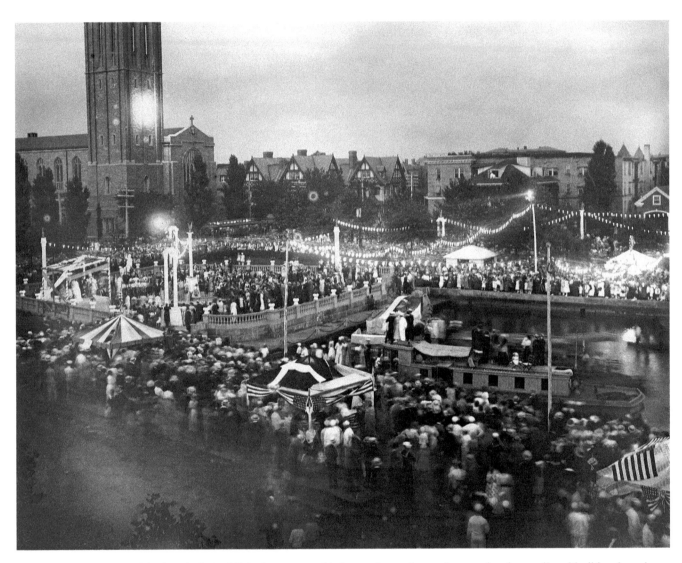

Taken in the Ghent neighborhood of Norfolk in June 1919, this image shows the newly completed seawall and bulkhead on the Hague, the western arm of Smith's Creek. The occasion was a summer festival called Welcome Home Week, held June 23–July 1. Electric lights illuminated the evening scene, which attracted sailors as well as local residents.

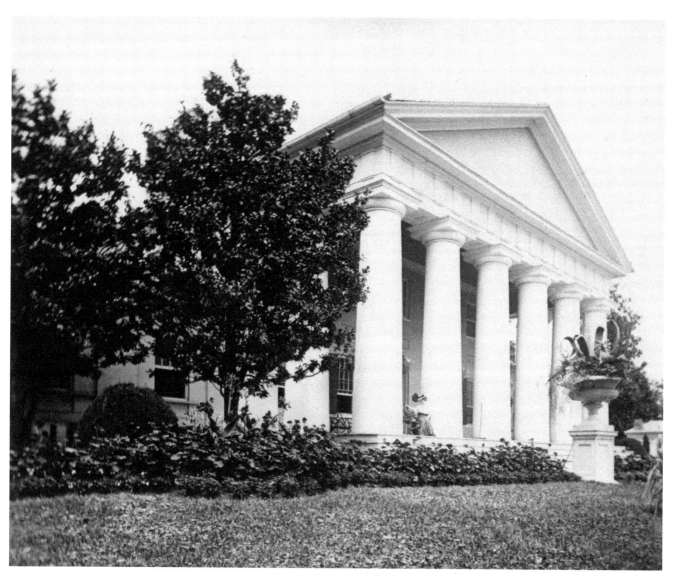

Arlington House, located in what is now Arlington National Cemetery, is shown here about 1918. It is often thought of as Robert E. Lee's house (it is called the Robert E. Lee Memorial), but although he lived there off and on before the Civil War, it was his wife's dwelling, which she inherited from her parents. When the Civil War began, the United States government seized the estate because Lee had resigned his commission in the United States Army, ending his 31-year career, and had taken the Confederacy's side. Partly in retaliation, the Army turned the beautiful grounds into a cemetery, embittering his wife, Mary Lee, for the rest of her life. Arlington National Cemetery was formally established there in 1874.

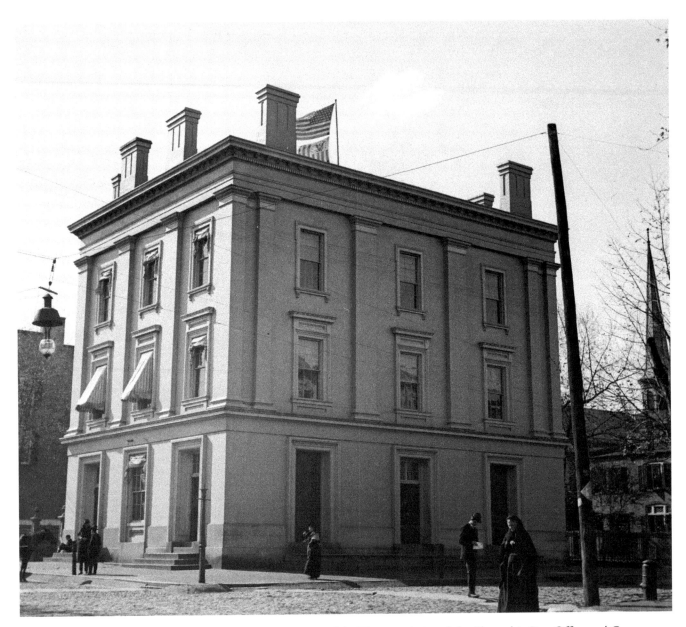

Ammi B. Young, the supervising architect of the Department of the Treasury, designed the Alexandria Post Office and Custom House, which was constructed in 1858 and is seen here around 1920. Young designed custom houses, post offices, hospitals, and courthouses across the United States. The fireproof building, which has been demolished, stood on the southwest corner of Prince and St. Asaph streets.

44

John Carlyle, a Scottish merchant and one of Alexandria's founders, completed this house in 1753, inspired by the compact early Georgian manor houses of Scotland. In 1755, General Edward Braddock met here with the governors of five colonies to plan a joint campaign against the French in the early stages of the French and Indian War, including his ill-fated expedition against Fort Duquesne (present-day Pittsburgh, Pennsylvania). The Carlyle House is one of Alexandria's jewels.

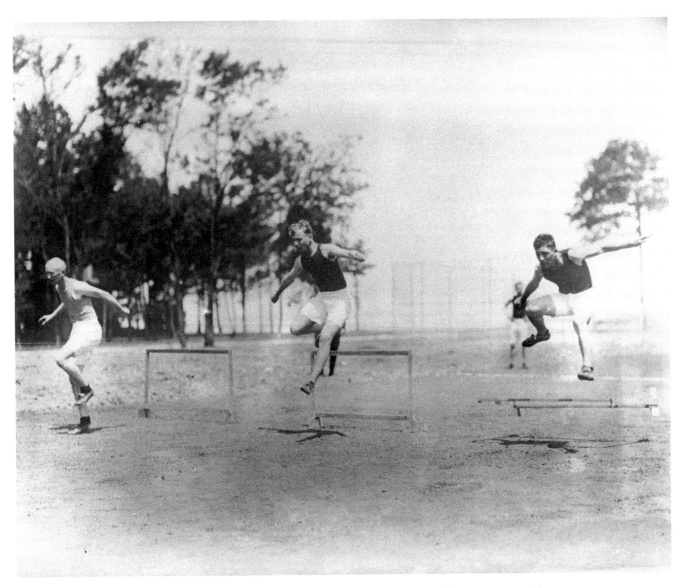

Navy men ran these 120-yard hurdles at the Naval Training Station in Hampton Roads on May 31, 1920.

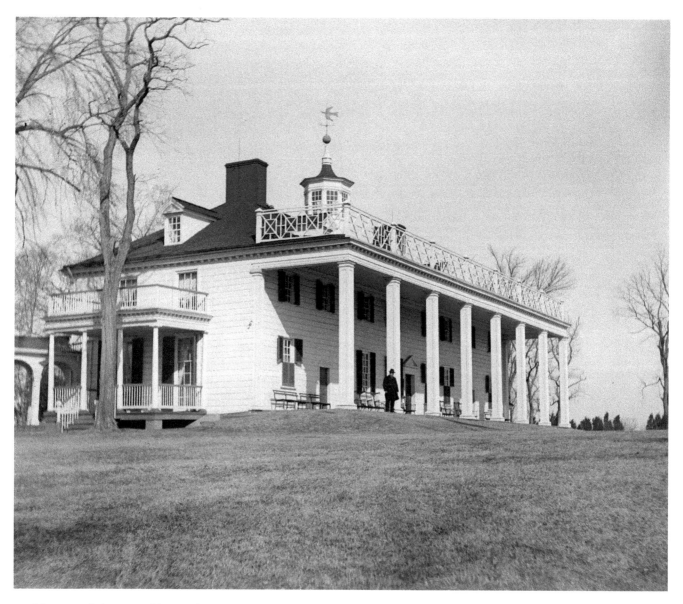

Now regarded as one of America's great treasures, Mount Vernon was admired but neglected for years after the death of George Washington, who inherited it in 1754 and remodeled it between then and 1787. In 1858, Ann Pamela Cunningham and the organization she spearheaded, the Mount Vernon Ladies' Association of the Union, purchased the house and 200 acres. Over the next century and a half, the mansion, outbuildings, and grounds would be meticulously restored. This photograph dates to about 1918–1920.

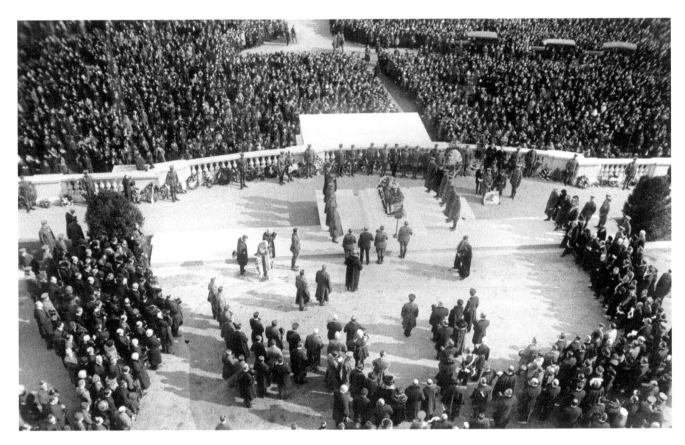

In October 1921, the bodies of four unidentified American soldiers were exhumed in France, and with solemn ceremony one was selected to represent all of the soldiers who gave their lives for the United States in World War I. The body was brought home aboard USS *Olympia,* transported to the Capitol to lie in state, and then carried in a parade through the streets of Washington to Arlington National Cemetery in Virginia. There, on November 11, he was laid to rest in what is now called the Tomb of the Unknown Soldier.

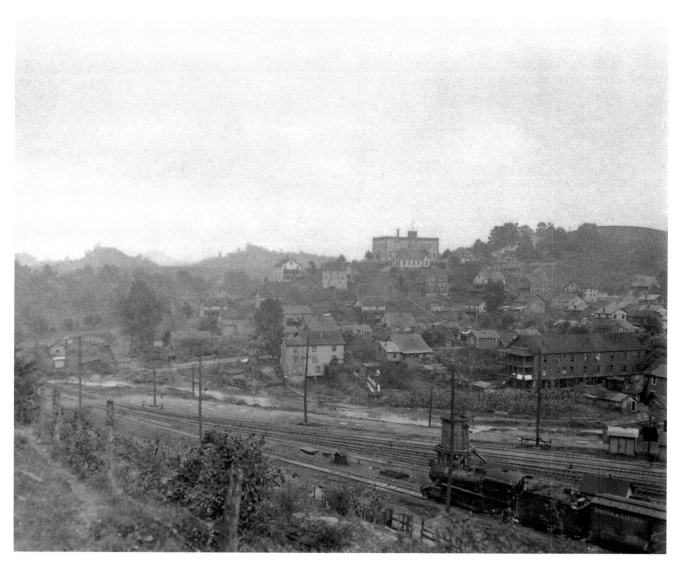

When enormous veins of coal were discovered in Tazewell County in Southwest Virginia early in the 1880s, a mining camp was quickly constructed. Soon, the coal-mine operators replaced the shacks with permanent structures, and the town of Pocahontas, seen here in the 1920s, became a model company town. Houses for families (with a separate section for African American miners), barracks for single men, churches, a synagogue, a combination jail building and opera house, stores, saloons, and other buildings covered the ground. A cemetery was opened on a hill overlooking the town. Pocahontas was listed on the National Register of Historic Places in 1972.

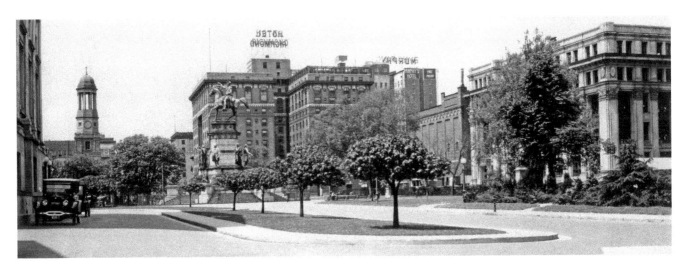

Most visitors today would recognize this 1923 view of Richmond's Capitol Square. At left is the back of the Capitol, the next building is Saint Paul's Episcopal Church, and the Hotel Richmond—now state offices—is behind the statue of George Washington on Ninth Street. The Murphy Hotel has recently been demolished. At right, the Life of Virginia insurance company building is now used by the Virginia General Assembly.

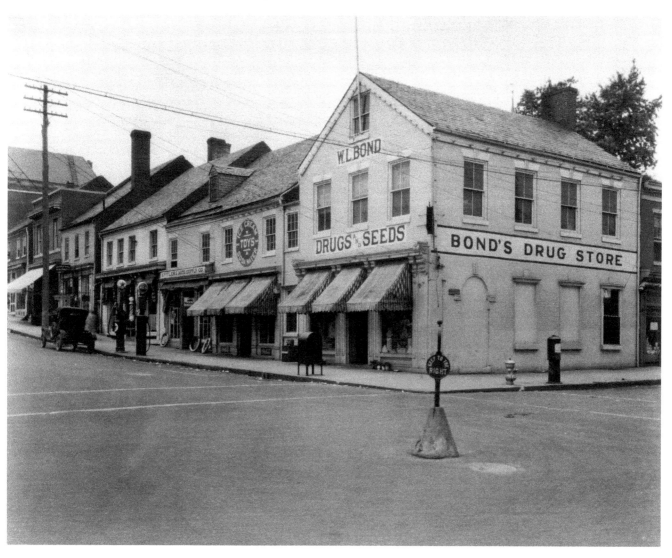

William L. Bond's Drug Store was photographed in Fredericksburg about 1925. It stood at 201–03 William Street, at the corner of Caroline Street.

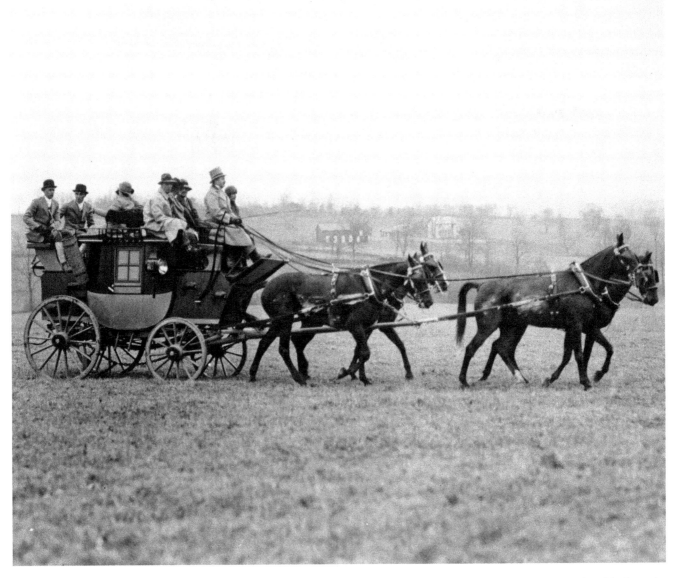

The Middleburg Hunt traces its origins to a contest held outside the town in 1905 between the owners of two packs of foxhounds, one American and one English. When the American hounds won, the Middleburg Hunt became established as one of the premier fox hunts in the United States. The Middleburg Hunt Cup is a steeplechase, first held cross-country but since 1932 conducted at the Glenwood Park course. Here W. P. Hulburt and his guests arrive at the Cup on April 3, 1926, the sixth annual race.

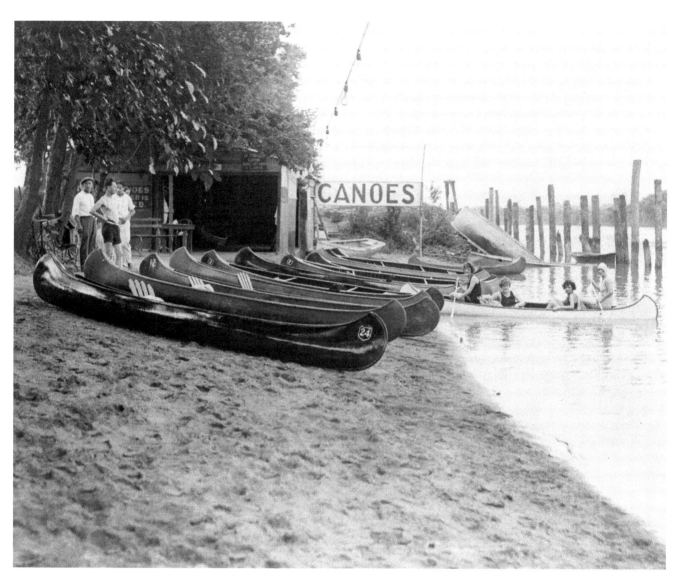

These canoers are enjoying Arlington Beach Park, which thrived in the 1920s on the south bank of the Potomac River near the present-day Fourteenth Street Bridge to Washington. On June 6, 1928, a monoplane on a test flight from Hoover Field (today's Washington National Airport) went into a tailspin over the park and crashed nearby, killing the pilot and mortally injuring the copilot.

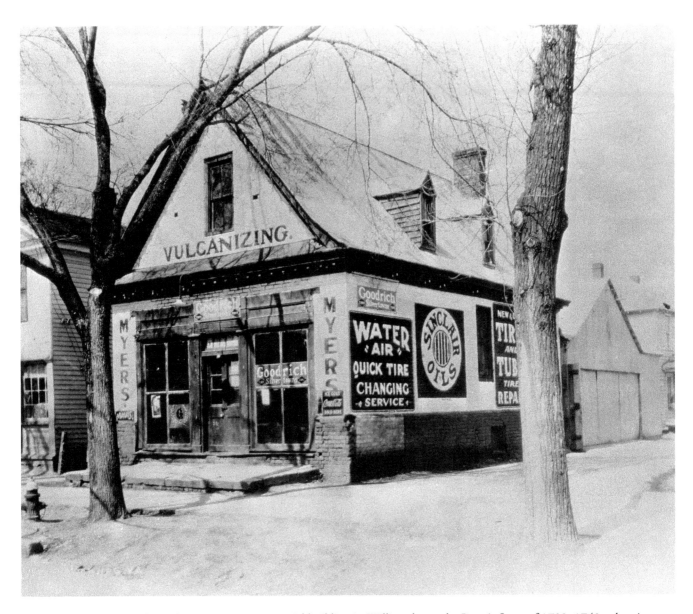

This photograph shows the earliest surviving commercial building in Williamsburg, the Prentis Store of 1739–1740, when it was an automobile service station before the first stages of the colonial capital's restoration in 1928–1931. Industrialist and philanthropist John D. Rockefeller, Jr., was persuaded by the rector of Williamsburg's Bruton Parish Church, Dr. William A. R. Goodwin, to underwrite the restoration and reconstruction of most of the town's pre-Revolutionary buildings. This store was among the first to be restored.

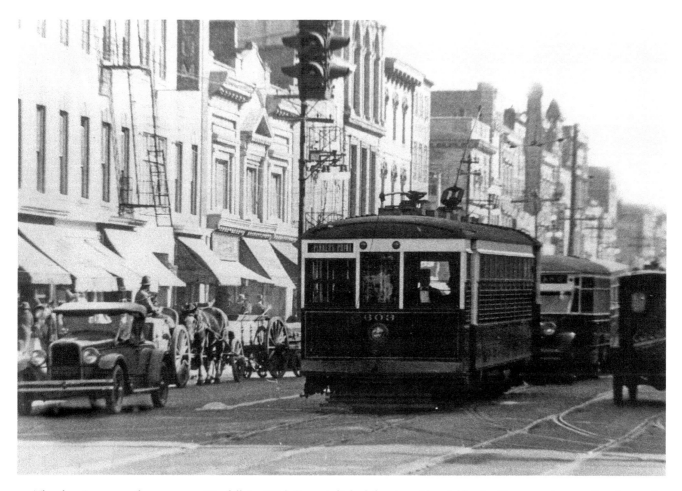

The electric street railway came to Norfolk in 1894. Soon, it linked the city with neighboring Portsmouth, as well as the nearby communities of Sewell's Point, Ocean View, South Norfolk, and Pinner's Point. The Pinner's Point streetcar shown here was photographed about 1928 in Portsmouth. In the background, behind the automobile, a horse and wagon are parked at the curb— echoes of the past.

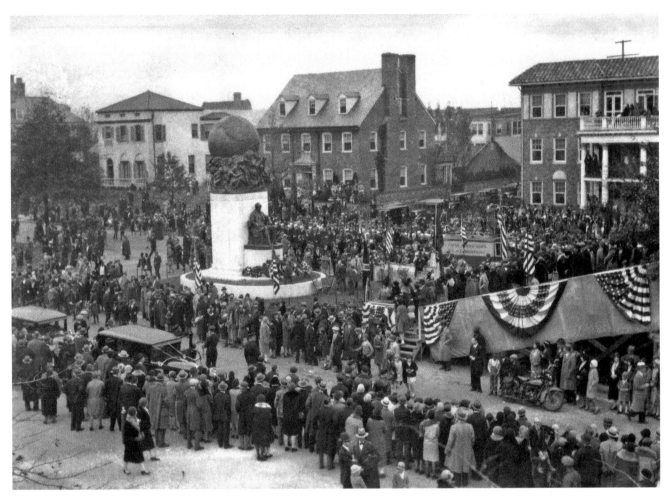

The statue of Virginia native Matthew Fontaine Maury (1806–1873), known as the "Pathfinder of the Seas," was unveiled during this ceremony on Richmond's Monument Avenue on November 11, 1929. Although Maury resigned his commission in the United States Navy to serve the Confederacy, he achieved his greatest fame before the Civil War, when he spent most of his career charting the world's oceans. He gained such international renown that foreign countries awarded him medals for making ocean travel safer. Ironically, Maury suffered from seasickness and a leg injury that made him unfit for sea duty.

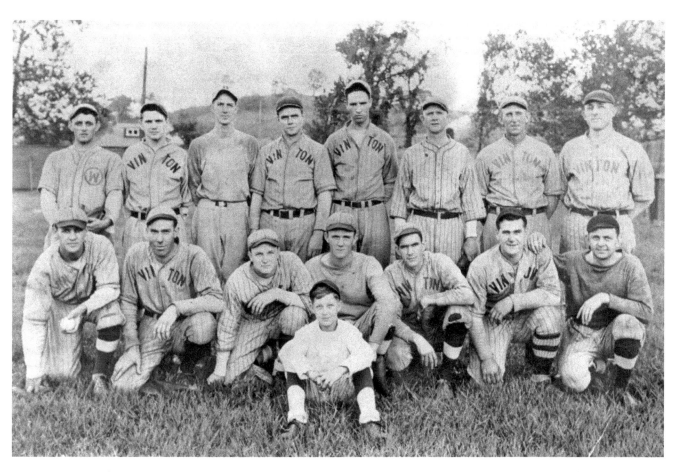

In the nineteenth century, the Norfolk and Western Railroad, like other companies of its time, formed baseball and other sports teams from among its employees. This picture of the Vinton team, located near Roanoke, was taken in 1928.

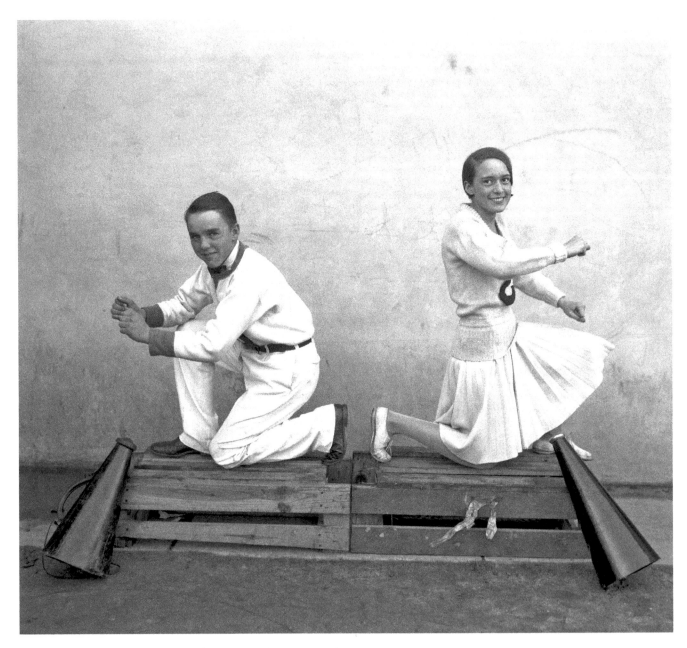

These Suffolk High School cheerleaders were ready to urge on their team in 1929.

DEPRESSION AND VICTORY

(1930–1945)

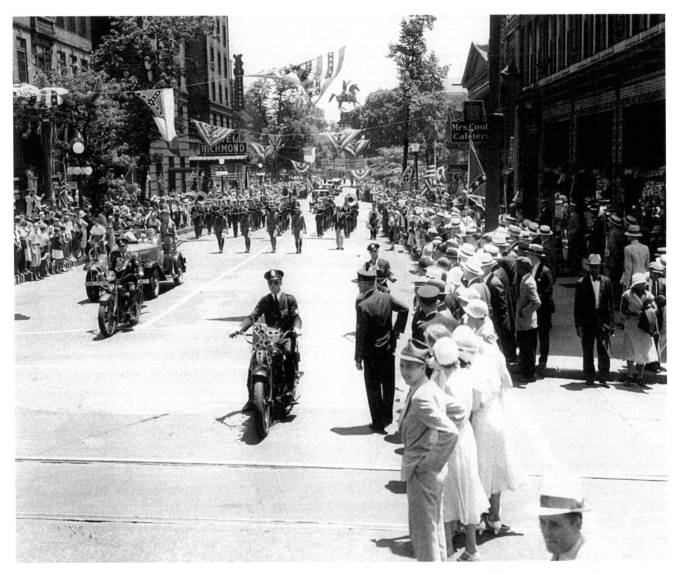

Richmond hosted the 42nd Confederate Reunion during June 21–24, 1932, the last time the old soldiers assembled for a major reunion. The grand review began at 11:30 A.M. on June 24 as dignitaries including Virginia's lieutenant governor, led by the grand marshal, left Capitol Square, as shown in this photograph. The Sons of Confederate Veterans joined the parade at the John Marshall Hotel, the Confederated Southern Memorial Association members fell in at the Jefferson Hotel, and finally the United Confederate Veterans joined at the R. E. Lee Camp Confederate Soldiers' Home. The parade then made its way past the statues of Stuart, Lee, Davis, and Jackson on Monument Avenue as vast crowds cheered.

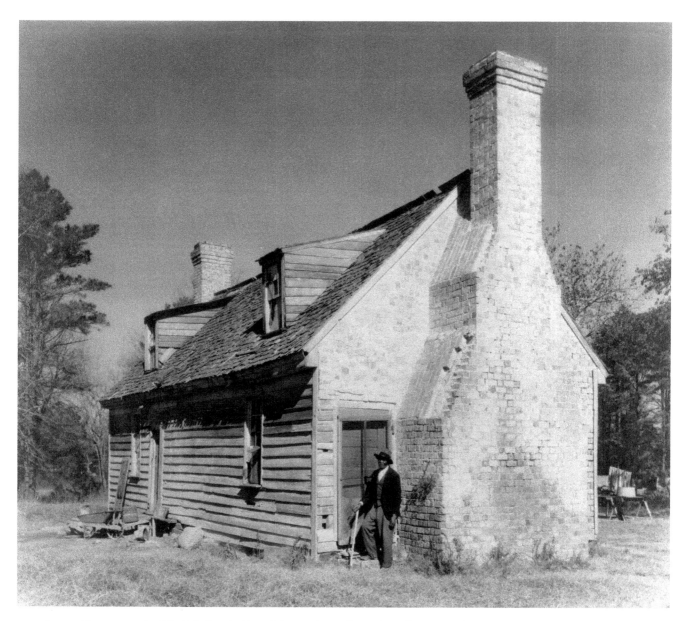

Located in present-day Virginia Beach (then Princess Anne County) in the 1930s, the Huggins House was believed to date to the seventeenth century. Few houses of that age survived into the twentieth century, but the building was of a general type found throughout Tidewater Virginia for almost 200 years. The frame, story-and-a-half dwelling with the massive exterior-end chimneys probably followed the hall-parlor interior plan, with a hall and enclosed staircase on the left and large parlor on the right.

Frances Benjamin Johnston took this picture of the miller's house at Cocke's Mill in Albemarle County in the 1930s. The two-story stone dwelling may date from shortly after the construction of the mill in the 1790s. Today, the mill is in ruins but the house still stands and is listed on the National Register of Historic Places.

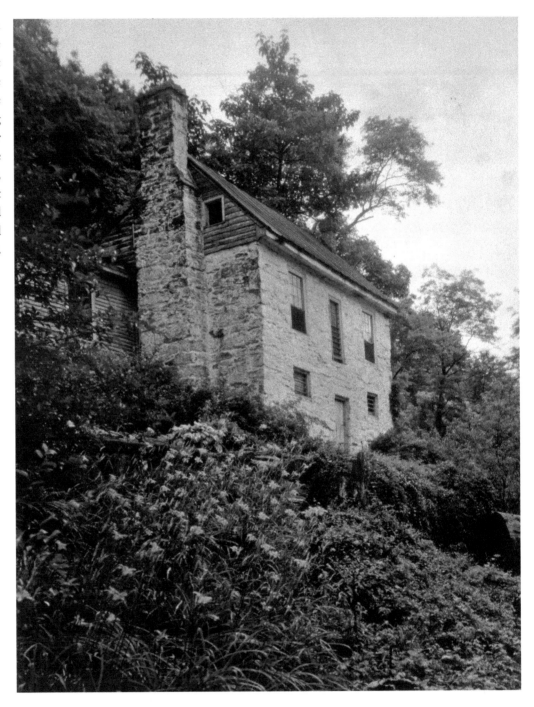

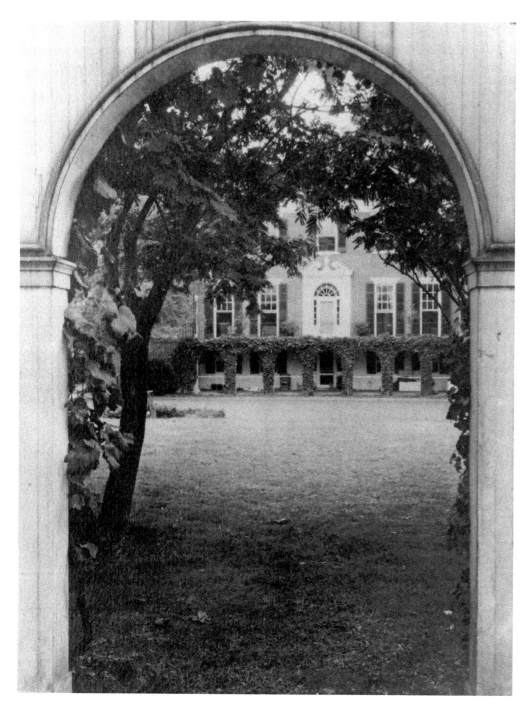

Mirador, a grand estate in Albemarle County near Charlottesville, was the childhood home of Nancy Witcher Langhorne, better known as Lady Astor, the first woman to be seated as a member of Parliament. In 1892, at the age of 12, she moved here with her family, including her beautiful sister Irene. Charles Dana Gibson, Irene's husband, is believed to have used Irene as the model for his "Gibson Girl" illustrations of the 1890s. This photograph was taken from the rear garden pavilion, probably in the 1930s.

When these two women were photographed at Virginia Beach in 1936, surfing was probably fairly new at the decades-old resort community. Invented in Hawaii, surfboards were produced in a variety of forms by the 1930s. This one may have been the hollow-box paddleboard type innovated by Tom Blake, whose boards became popular because they were relatively light despite their lengths of 13 feet or more.

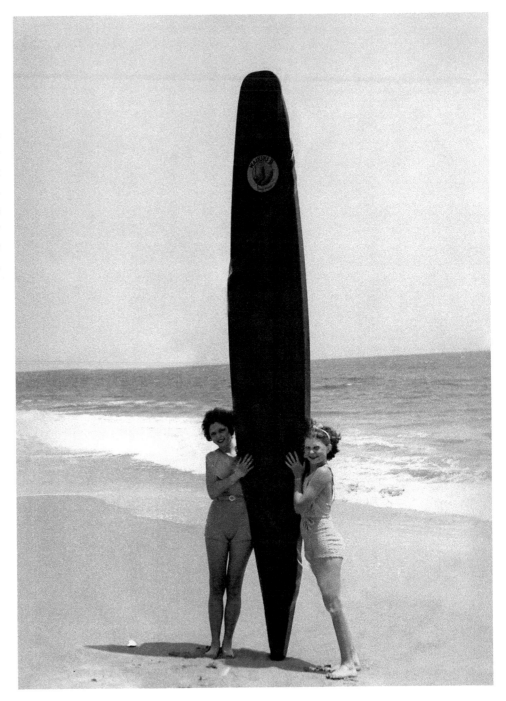

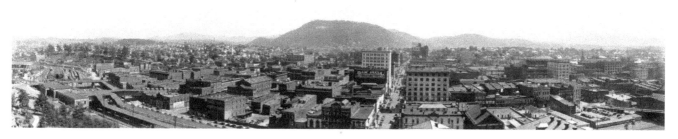

Roanoke, the Southwest Virginia city that grew up in the late nineteenth century around a community called Big Lick, owed its early growth to Big Lick's emergence as a post–Civil War rail center. In 1881, the town changed its name to Roanoke and soon became a bustling metropolis. This 1931 panoramic view shows Mill Mountain looming in the distance. Civic boosters erected a huge neon star atop the mountain in 1949, giving Roanoke its nickname, "Star City of the South."

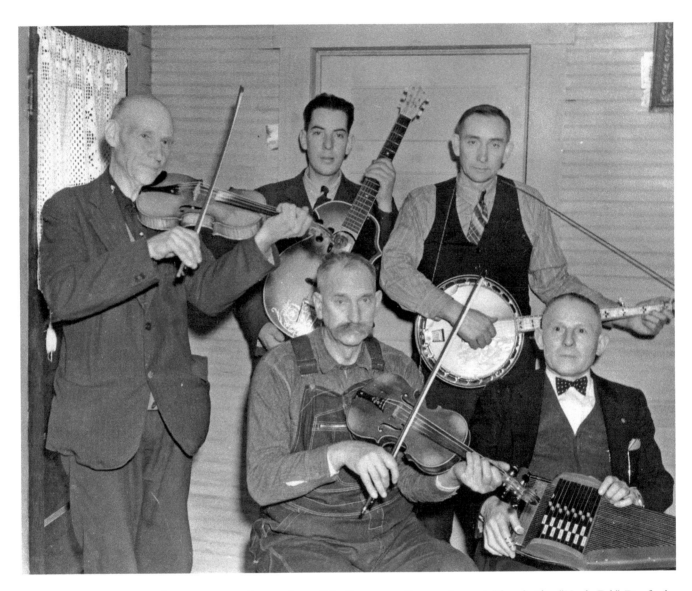

Pictured here in 1937 at Galax, Virginia, are the members of the Bogtrotters "mountain music" band. Alex "Uncle Eck" Dunford is at left, with Fields Ward and Wade Ward standing, and Davey Crockett Ward and Dr. W. P. "Doc" Davis sitting. Wade and Crockett Ward were brothers; Fields Ward was Crockett's son, Dunford was a neighbor, and Davis was the local physician. Mountain music had its roots in the folk music of the Scots-Irish immigrants who settled in the backcountry of Pennsylvania, Virginia, the Carolinas, Georgia, Tennessee, and Alabama beginning in the eighteenth century. Galax, in Southwest Virginia, has been home to the annual Old Fiddler's Convention since 1935. It is one of the largest such gatherings in the nation.

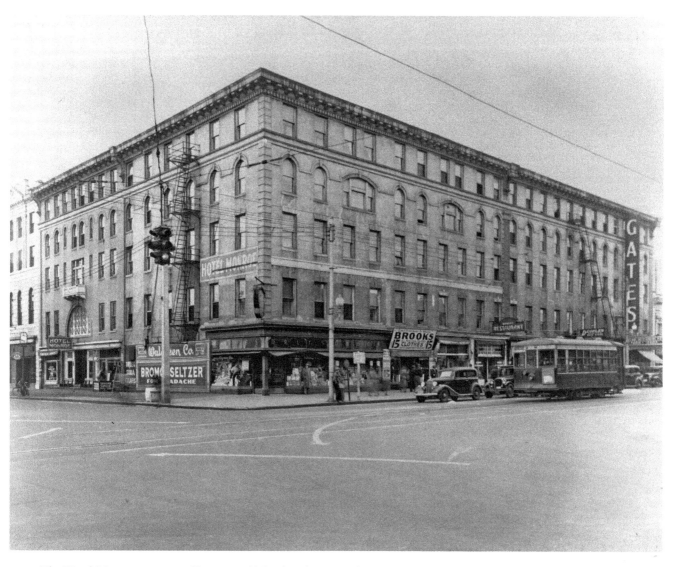

The Hotel Monroe was one of Portsmouth's landmarks. Erected in 1856, it was first called the Ocean House, and during the Civil War it served at different times as Confederate officers' quarters and as a Union hospital. Seen here in 1938, it burned on August 9, 1957.

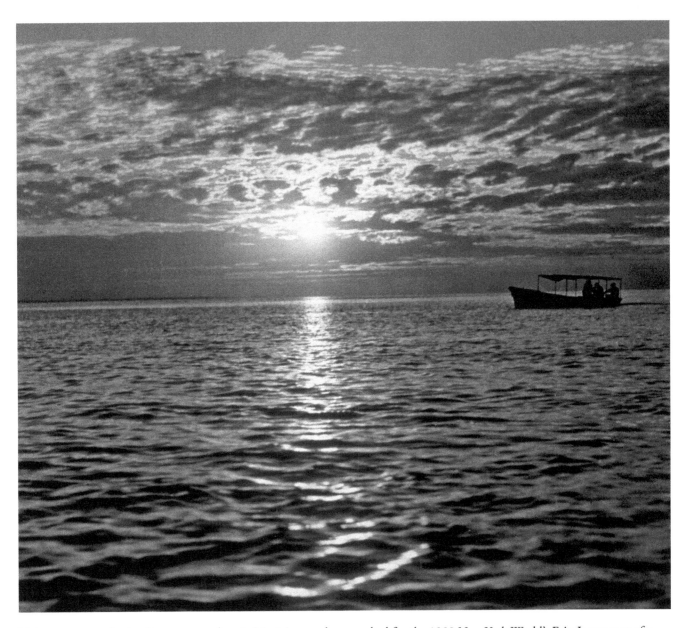

This sunset over a body of water somewhere in Virginia was photographed for the 1939 New York World's Fair. It was part of a collection of pictures displayed in bound volumes on different subjects in the Virginia Room exhibition.

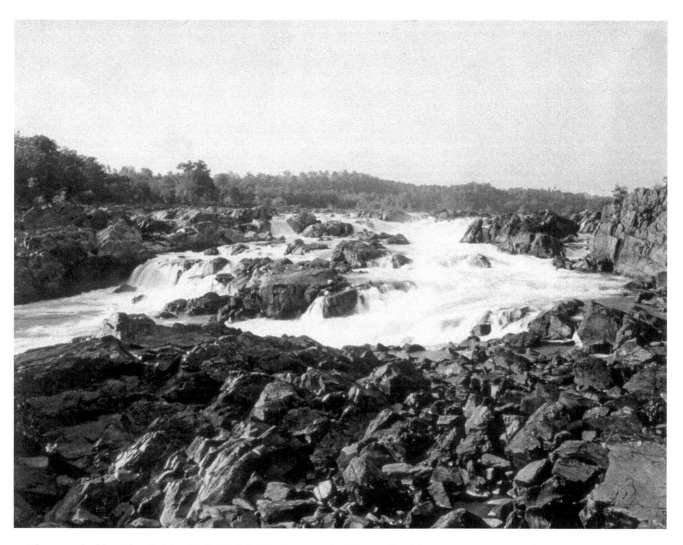

Photographed here for the New York World's Fair in 1939, the Great Falls of the Potomac River may have been seen by Captain John Smith in 1608, when he explored the Chesapeake Bay and many of its tributary rivers.

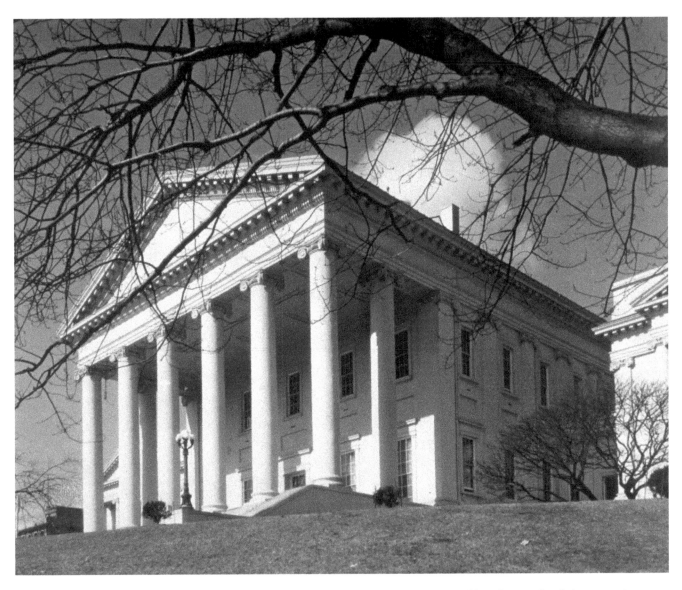

Thomas Jefferson's temple of democracy, the Virginia State Capitol, was begun in 1785 and largely completed three years later. Seen here in 1939, the building is still in use as the home of the oldest legislative body in the New World. During the Civil War, the Confederate Congress met there. Afterward, in 1870, a floor collapsed in the old Senate chamber, killing more than 60 people and injuring hundreds. Renovations were later made, and in 1904–1906, two flanking wings were added.

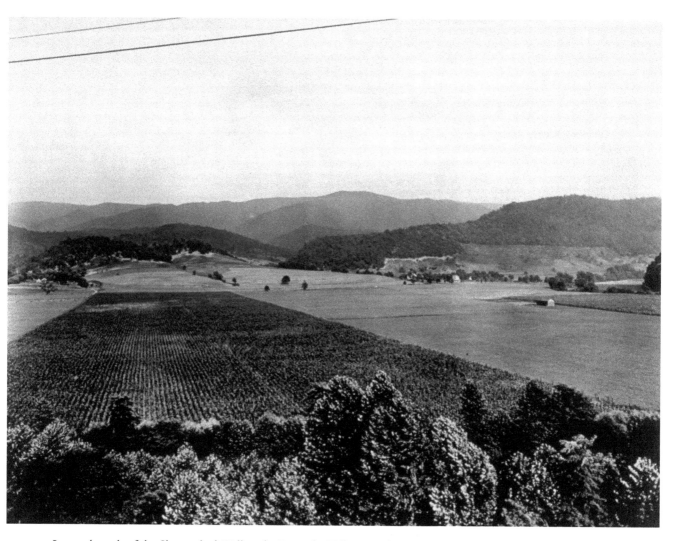

Located south of the Shenandoah Valley, the Roanoke Valley was photographed in 1939 for the collection of images to be displayed in bound volumes in the Virginia Room exhibition at the New York World's Fair.

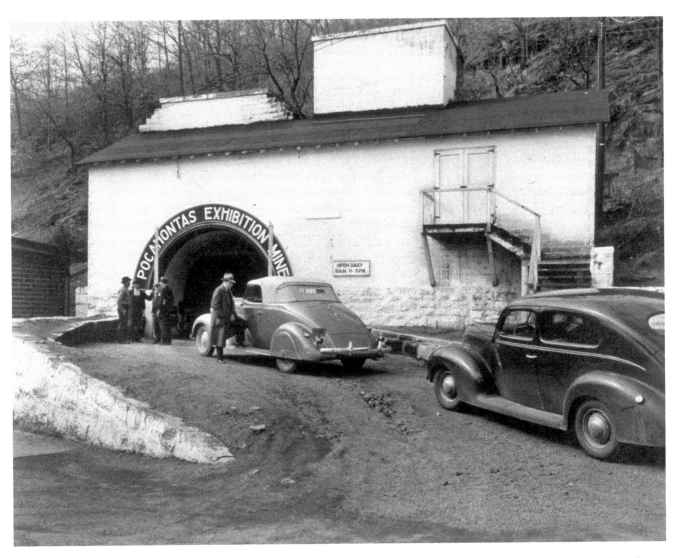

Here about 1939, and for many years thereafter, visitors to the Pocahontas Exhibition Mine in Tazewell County could drive their vehicles through the mine, where the floor, walls, and ceilings were of coal. This was Mine No. 1 for the Pocahontas–Flat Top Coal Field, opened in 1882 near where the 13-foot-thick coal veins were discovered. The mine, which pioneered the coal-mining era in Southwest Virginia as well as in West Virginia, closed in 1955. In 1994, the mine was designated a National Historic Landmark.

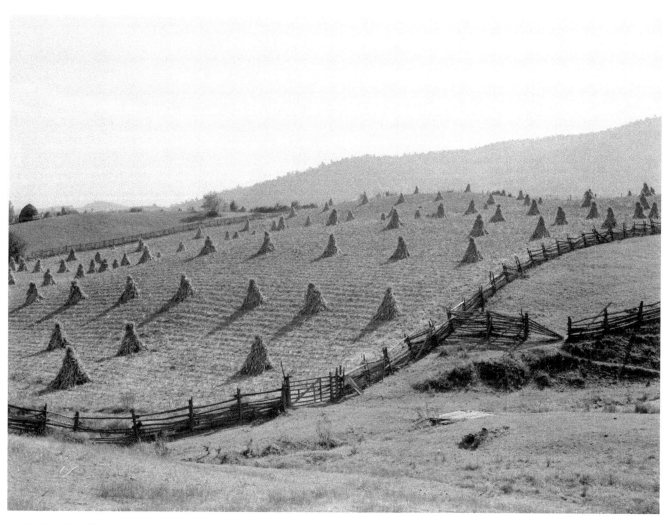

Marion Post (known as Marion Post Wolcott after her 1941 marriage to Lee Wolcott) photographed these corn shalks in Smyth County in Southwest Virginia in October 1940. She was a Farm Security Administration photographer from 1938 to 1941 and worked extensively in the South.

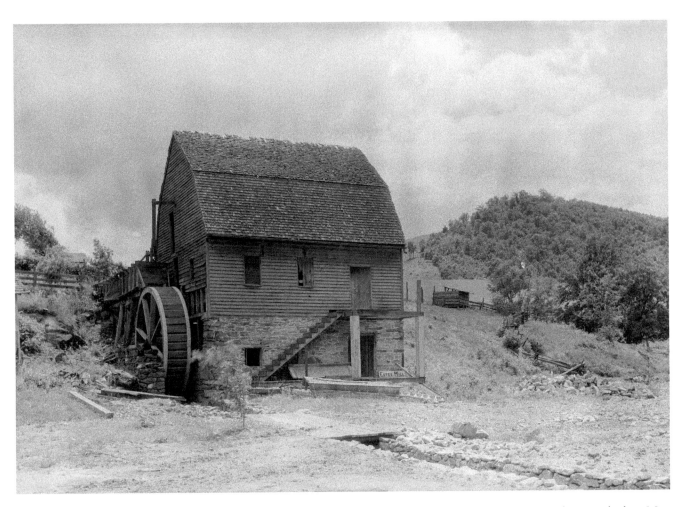

The Estes Mill is located in Rappahannock County, at the eastern foot of the Blue Ridge Mountains. It was photographed on May 29, 1941, by a photographer employed by the Historic American Buildings Survey, which the National Park Service established in 1933. Now called HABS or HAER (the latter for Historic American Engineering Record), the survey continues to document the nation's architectural heritage. The Estes Mill still stands, although it has been much altered.

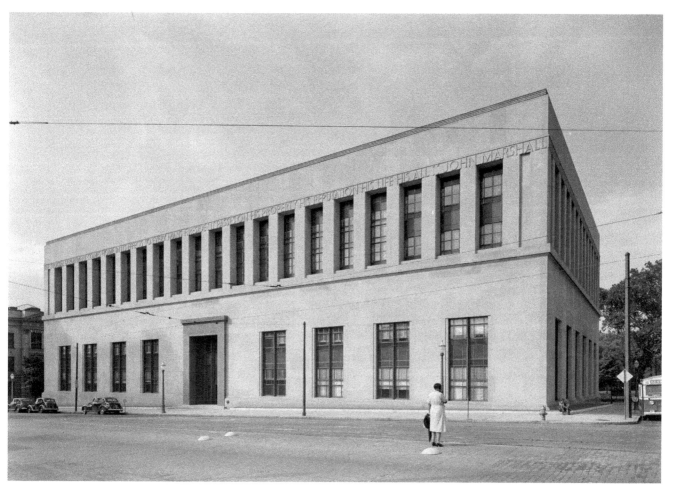

This photograph of the Virginia State Library and Virginia Supreme Court building was taken July 11, 1941, from the north side of Broad Street in Richmond. The library and court moved to this Art Deco–style building across Governor Street from Capitol Square in December 1940. The court entrance is shown here; the library was entered from the Capitol Square side. Later, additional stack space was constructed on top of the building. The court moved to new quarters in the 1980s, and the library, now called the Library of Virginia, occupied a new building a few blocks west on Broad Street in December 1997. Today, the governor's office and other state offices are located in this structure.

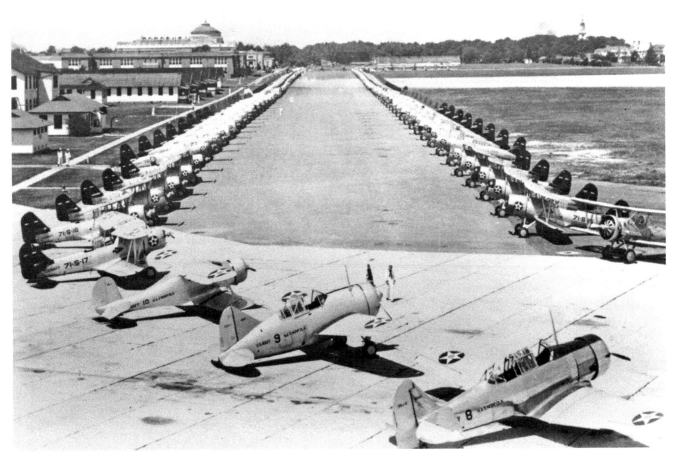

When World War II began, America's armed forces still flew biplanes in addition to single-wing fighters. Here, at the Norfolk Naval Operating Base, old biplanes are lined up on the left and right, with three new single-wing fighters in the foreground. Published in August 1942, the original caption for this image read: "A vastly expanded air station at the Norfolk Naval Operating Base bears eloquent witness to the growing might of the Navy's air arm."

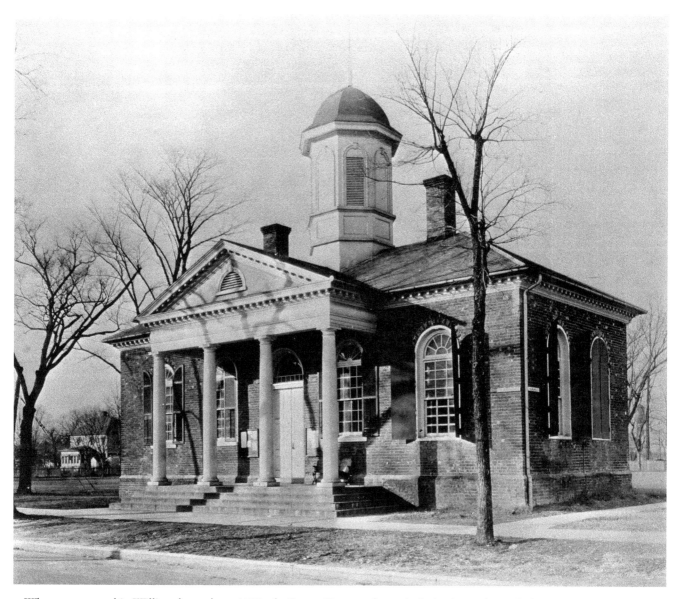

When constructed in Williamsburg about 1770, the James City courthouse lacked columns beneath the portico; apparently they were ordered from England but did not arrive before the Revolutionary War put an end to commerce between Virginia and the mother country. Through the Revolution and the Civil War, the building survived columnless. It burned in 1911, although the walls survived, and columns were installed as the damage was repaired. Following the restoration and re-creation of Colonial Williamsburg that began in the 1920s, the columns were removed to return the courthouse to its colonial appearance.

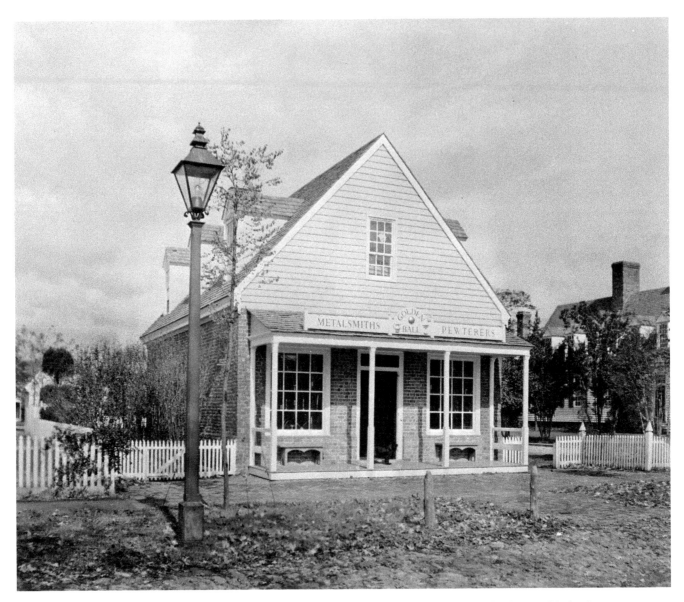

Margaret Hunter's Millinery Shop (shown here when it was being interpreted as the Golden Ball silversmith's shop) in Williamsburg retained much of its colonial-era architectural fabric when it was photographed about 1943. Since the picture was taken, the porch has been removed but otherwise the building appears much the same. Those that stood around it when Williamsburg was Virginia's colonial capital have been reconstructed, including the Golden Ball silversmith shop, which was actually located to the right of Margaret Hunter's.

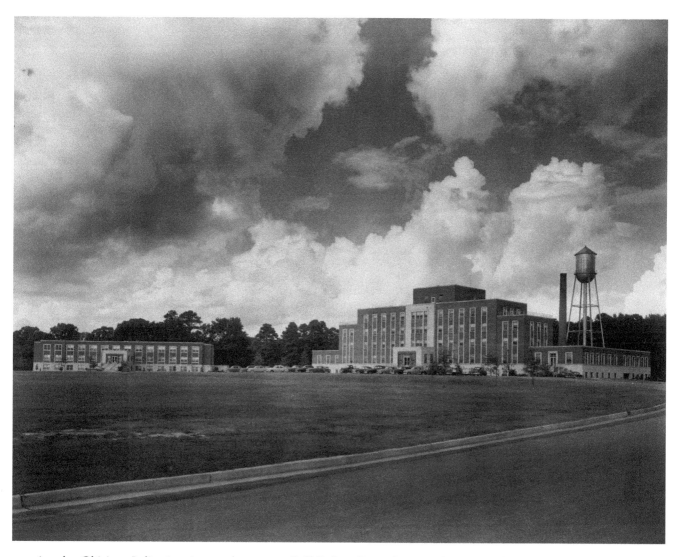

Amedeo Obici, an Italian immigrant who came to Suffolk from Pennsylvania and constructed the enormous Planters Nut and Chocolate Company peanut-processing plant in the 1920s, was a noted philanthropist as well as an industrialist. He funded this hospital in Suffolk in the 1940s to honor his late wife, Louise Obici, who had died in 1938.

Late in the summer of 1940, the War Department selected Caroline County in central Virginia as the site of a heavy-weapons and maneuver-training facility for the Army. Approximately 60,000 acres were appropriated, and Military Reservation A. P. Hill was established on June 11, 1941. The creation of the post required the eviction of many farm families, such as that of Russell Tombs, shown here packing household goods on a truck while Mrs. Tombs watches from the doorway. Named for a Confederate general, the installation served as a World War II training ground for, among other units, Major General George S. Patton's Task Force A, which invaded French Morocco in North Africa. It is still an active post, known today as Fort A. P. Hill.

Taken Christmas morning 1944 at the Hampton Roads Port of Embarkation, this image demonstrated that World War II did take some holidays off. The original caption noted, "The morning is spent on regular duties, and in drawing the supplies which will be needed for action overseas. But the Army can be sentimental when it has the time; except for the luckless few on details, most of [this] outfit will have the afternoon free."

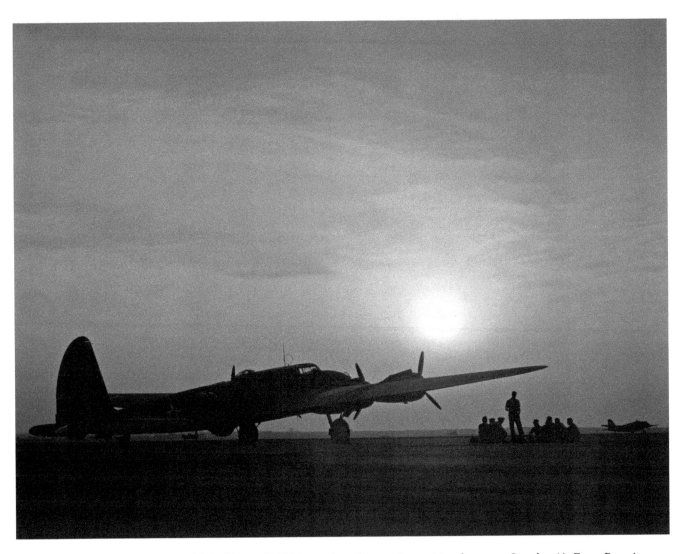

Langley Field in Hampton was established in 1916–1917 to train military aviators. Now known as Langley Air Force Base, it was home to the First Service Group (the present-day First Air Force) beginning in June 1942. The next month, one of the group's B-17 bombers, known as the Flying Fortress because of its heavy armament, was photographed against a spectacular sunset.

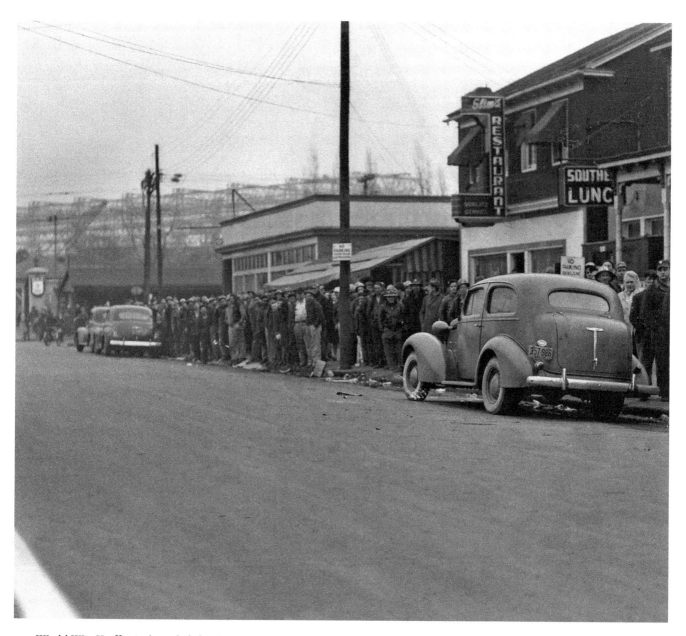

World War II effectively ended the Great Depression, creating a huge demand for workers in war-related industries. This 1944 image shows a large number of employees of the naval shipyard in Portsmouth waiting for buses outside the Fourth Street gate.

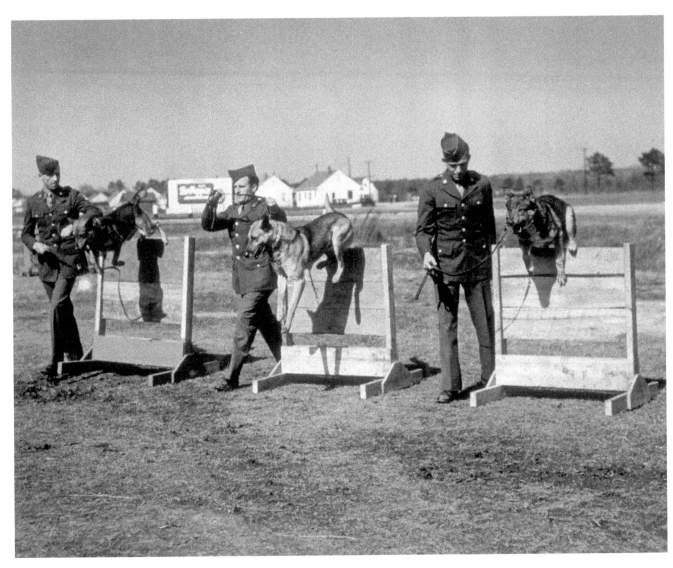

These dogs are undergoing final training with their handlers, all military policemen, for service as sentries. They were photographed in Hampton Roads on February 23, 1945. Left to right are Pfc. William A. Irvin, of Bellefonte, Pennsylvania, with Rex; Pfc. Norman S. Olson, of Stoughton, Wisconsin, with Pete; and Pvt. Howard A. Smith, of Philadelphia, Pennsylvania, with Chris. The United States Army Quartermaster Corps operated a War Dog program beginning on March 13, 1942, to train dogs for duty as sentries, scouts, messengers, and mine detectors. Five training centers were established—the first was in Front Royal, Virginia—and the training program lasted 8 to 12 weeks.

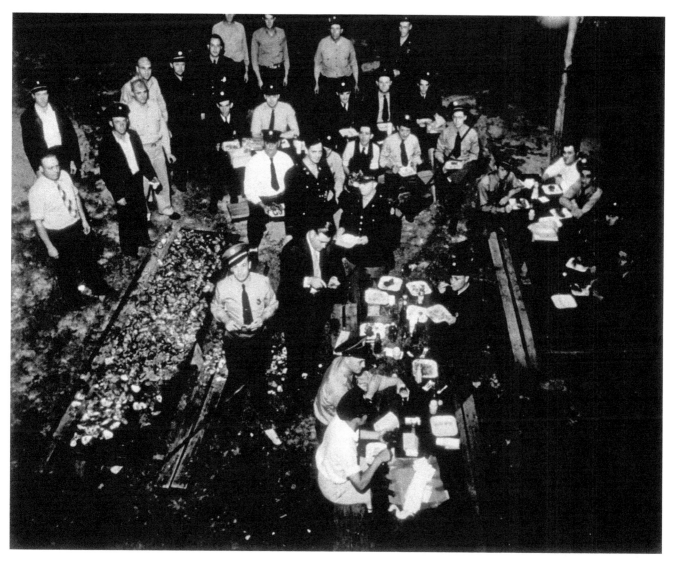

Camp Patrick Henry, a temporary World War II staging area, was located on 1,700 acres on the western edge of Newport News. There, almost one and a half million soldiers were organized and supplied before sailing overseas. The Newport News/Williamsburg International Airport occupies much of the site today. This image shows an oyster roast held April 4, 1945, after the firemen's graduation exercises. The three officers standing in the middle are Captain George F. Michael, of Red Hook, New York; Captain James V. O'Sullivan, of New York City; and Captain Paul W. Brown, of Philadelphia.

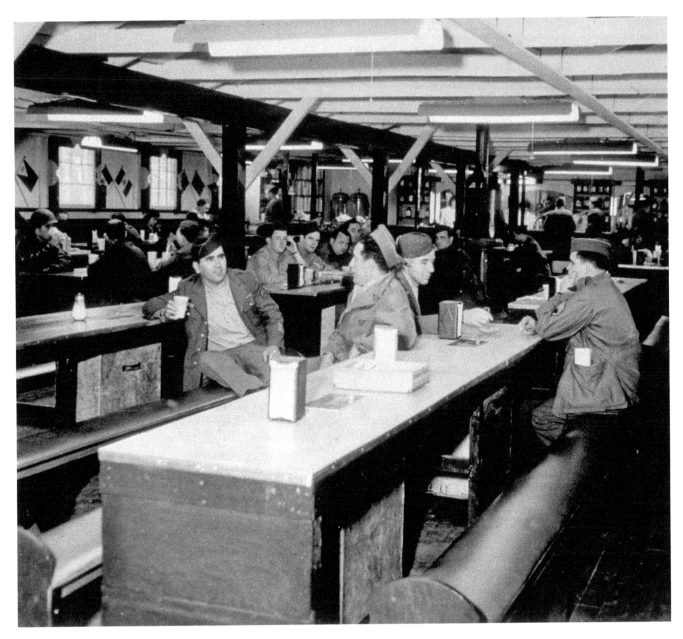

Camp Patrick Henry, in Newport News, processed returning soldiers as well as those bound for embarkation. These men, photographed May 1, 1945, are enjoying a between-meals snack in the camp's milk bar after debarking. The milk bar was so popular with returning veterans that lines often stretched out the door.

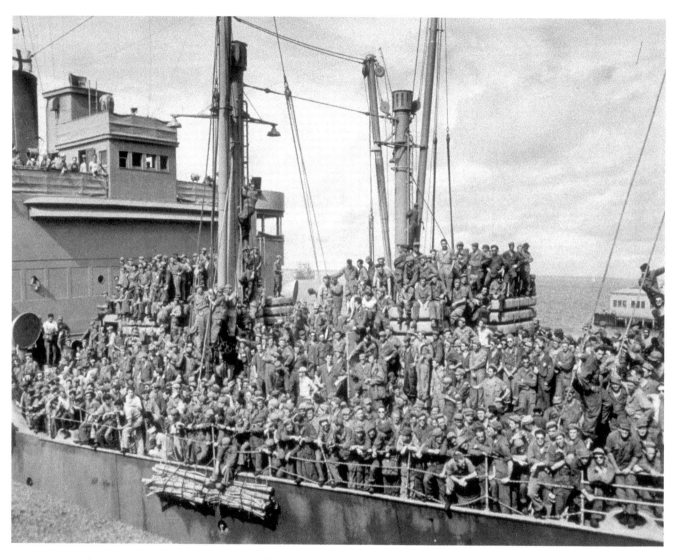

It took many months for most of the soldiers to return to the United States after World War II ended. On September 14, 1945, USS *J. W. McAndrew* pulled in to Pier 8 in Hampton Roads with a cheering crowd on board. The vessel had sailed from Marseilles, France, 10 days earlier with 2,442 passengers, including 248 officers, 2,193 enlisted personnel, and one American Red Cross worker.

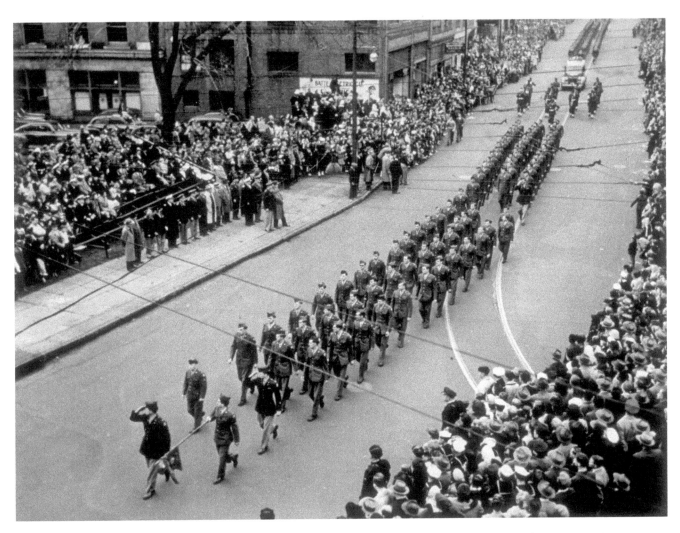

The veterans of two world wars were honored in a parade held in Norfolk on November 12, 1945, the first Armistice Day remembrance following World War II. Here personnel of the Norfolk Army Base are passing the reviewing stand on Granby Street.

A Time of Great Change

(1946–1970s)

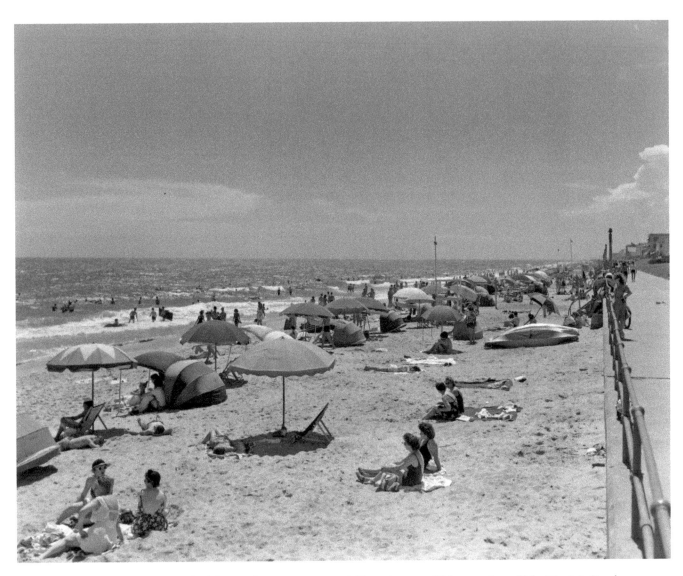

Life after World War II quickly shifted from military concerns to civilian pleasures. This scene just off the Virginia Beach boardwalk is from 1946.

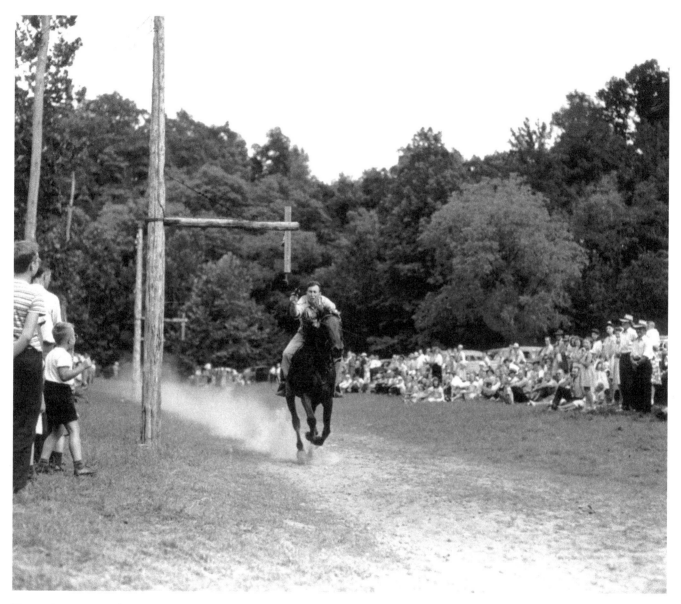

Equestrian games and tournaments, as well as horse racing, have long been popular in Virginia. In this 1946 tournament at Mount Solon in Augusta County, a rider at full gallop attempts to spear a succession of steel rings hanging from posts. This is modern jousting—a far cry from the good old days when knights on horseback tried to spear each other instead of rings. The Mount Solon tournament is said to date to 1821 and is held each year in August, with crowds of onlookers numbering in the thousands.

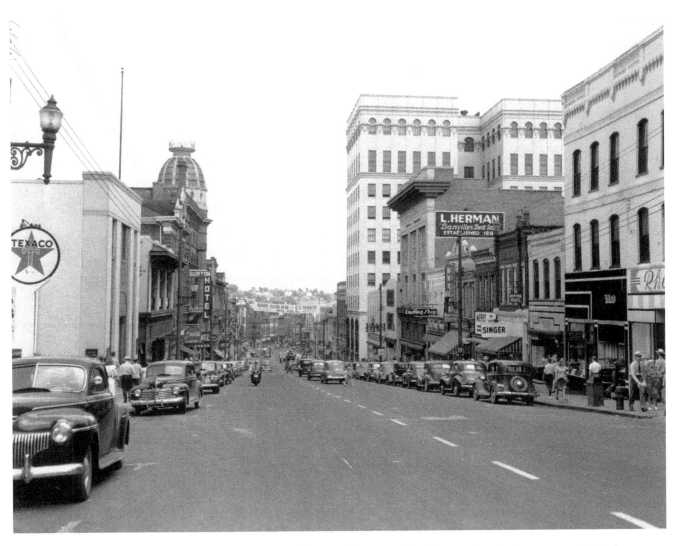

Taken shortly after World War II, this image shows Main Street in downtown Danville, a mill and tobacco center in Piedmont Virginia near the North Carolina line. The buildings shown here now compose the Downtown Danville Historic District. Constructed in 1921-22, the tall white building is the Masonic Building, one of Danville's two skyscrapers. The Roman Eagle Lodge built the structure not only for lodge meetings on the topmost floors, but also as rental space for businesses and offices.

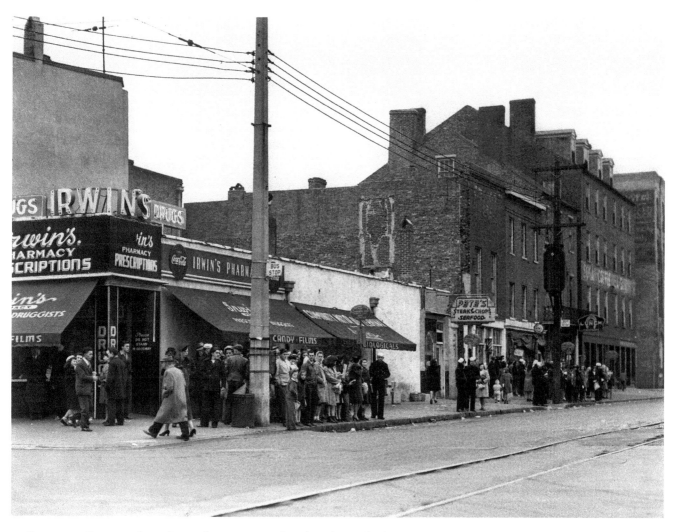

Downtown Portsmouth, at the northwest corner of High and Crawford streets, was photographed about 1947. Naval personnel and civilians in front of Irwin's Pharmacy await a bus.

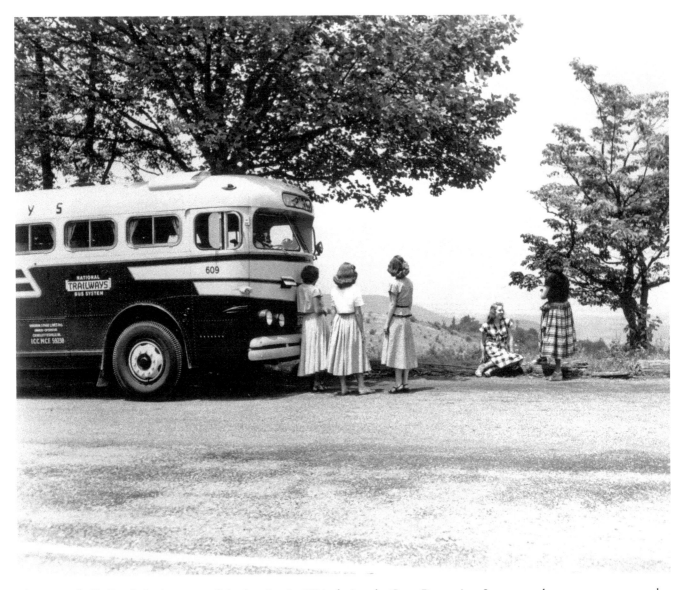

The 105-mile Skyline Drive began as a federal project in 1931, during the Great Depression. It gave employment to many people, especially local residents in the Blue Ridge Mountains, in present-day Shenandoah National Park. The last segment was completed in 1939, and since that time millions have driven the high, winding road and enjoyed the spectacular mountain scenery and views. This group of tourists stepped out of their Trailways bus in 1948 to have a look.

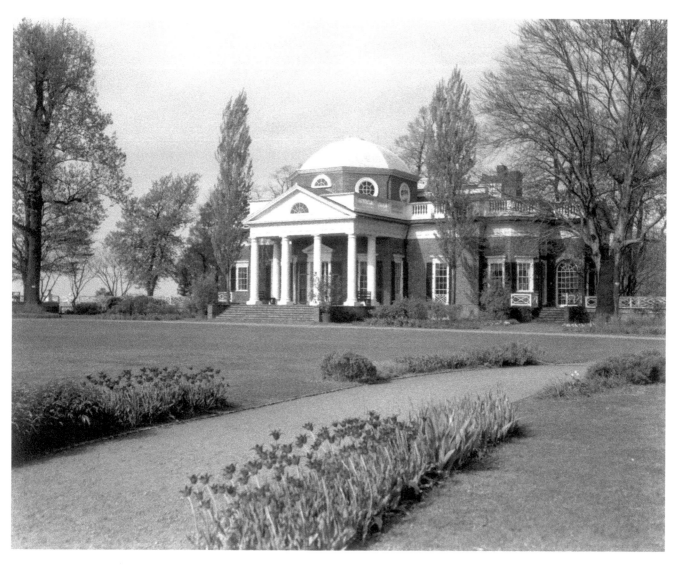

Seen here in 1948, Monticello, the home of Thomas Jefferson in Albemarle County, is one of Virginia's many popular tourist attractions, averaging about half a million visitors annually. Since Jefferson Monroe Levy, the last private owner, sold Monticello to the Thomas Jefferson Foundation in 1923, a vast amount of work has taken place. The Foundation has restored the house, gardens, and grounds to their appearance in Jefferson's time, many original pieces of furniture and artifacts have been returned, and the setting and views from the mountaintop are as spectacular now as they were when he lived there.

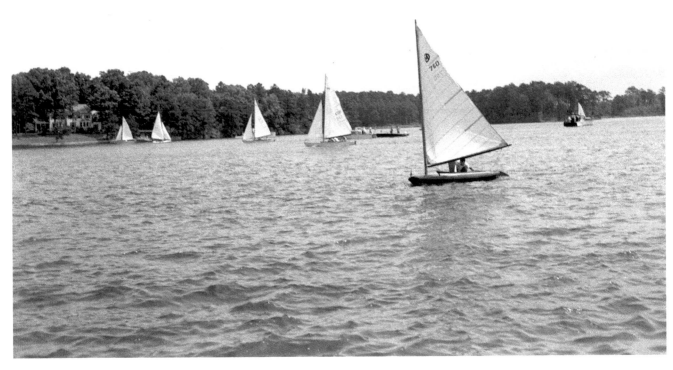

Recreational boaters, commercial and amateur fishermen, and naval vessels have long plied the rivers and inlets of the Hampton Roads area. These sailboats were photographed on Linkhorn Bay in Virginia Beach in 1948.

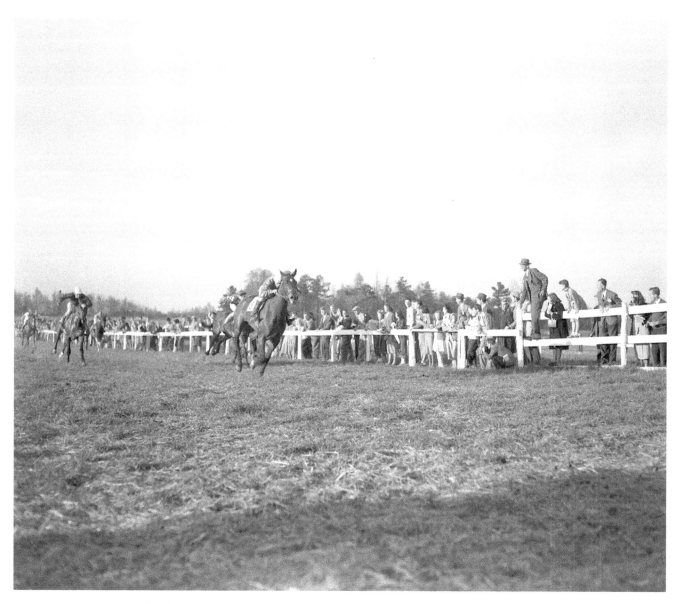

Many people are familiar with dirt-track horse-racing, but turf racing and steeplechase racing have always been popular in Virginia. The Deep Run Hunt Club, located west of Richmond, was founded in 1887 as a foxhunting club. It held its first steeplechase in 1895; after changing venues, the race was established at Strawberry Hill in 1947, on the Virginia State Fairgrounds. This image is from the 1948 race there. In 2000, the race was moved to Colonial Downs in New Kent County, east of Richmond, and is held there every April.

This image, taken in 1948, shows part of the commercial area known as Merchants Square, located at the western end of Colonial Williamsburg near the College of William and Mary. As it was already the town's commercial center when the restoration began late in the 1920s, this two-block area was readily adapted to redevelopment for tourists as well as local residents. New buildings were constructed with Colonial Revival–style facades based on commercial structures in Alexandria and in Annapolis, Maryland, and in other cities with surviving colonial buildings.

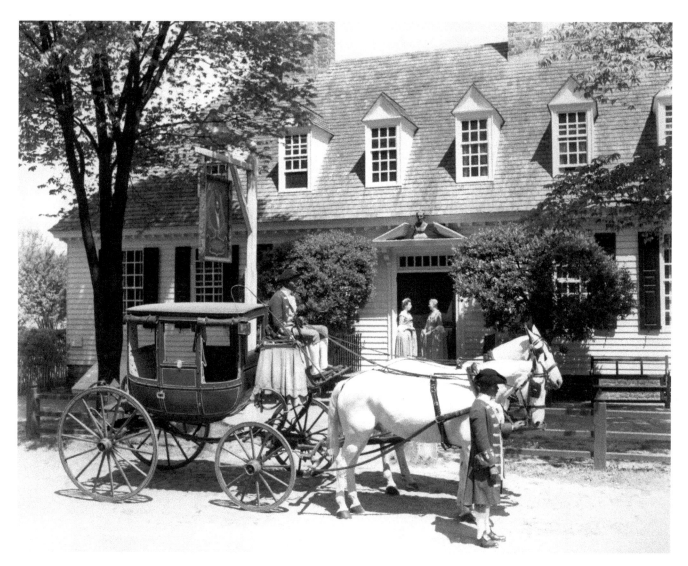

By 1948, when the reconstructed Raleigh Tavern was photographed, Colonial Williamsburg had found its formula: employing local residents as costumed interpreters amid restored or reconstructed buildings to give visitors an "authentic" colonial experience. The definition of authenticity has changed over the years, as archaeological discoveries and the close study of official records and personal papers have revealed new truths about the colonial world. Fewer and simpler furnishings, bright wall colors instead of the "Colonial Williamsburg" dusty rose and other pale shades that were found to be the result of two centuries of fading in the sunlight, and the interpretation of the lives of enslaved people as well as of the white upper crust—all have come to Williamsburg in recent times.

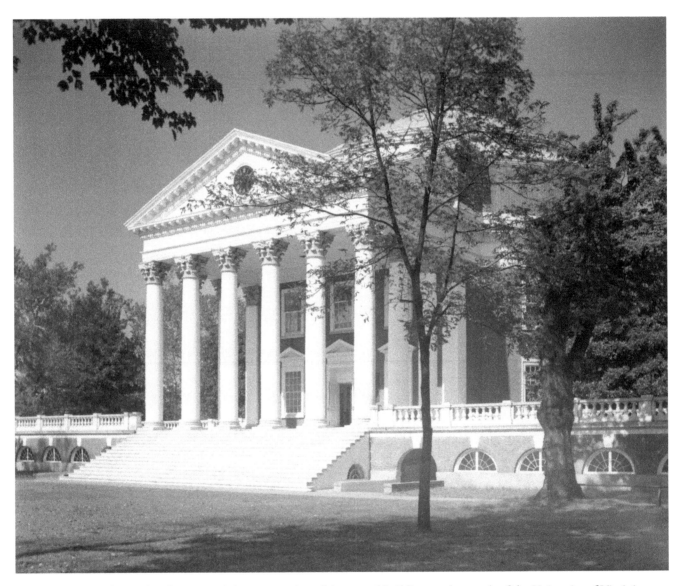

Thomas Jefferson designed and supervised the construction of the central buildings and grounds of the University of Virginia between 1814 and 1826. The focal point of his "Academical Village"—a terraced lawn enclosed on three sides with colonnaded student rooms and professors' pavilions—is the Rotunda, which served as the library until the interior burned in 1895. Based on the Pantheon in Rome, the Rotunda is an example of what Jefferson called "spherical" architecture. New York architect Stanford White designed a new interior after the fire. It was removed in the mid-1970s and the Jeffersonian interior was reconstructed. This photograph was taken in 1948.

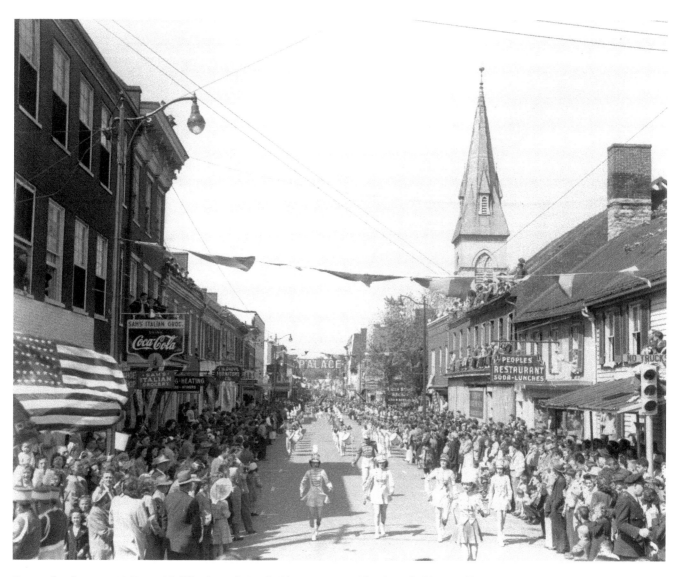

Except for the years 1942–1945, Winchester's Apple Blossom Festival has been held annually since 1924 to celebrate the blooming of the area's apple trees. The northern end of the Shenandoah Valley has been Virginia's center of apple production for almost a century. Every year, the festival has grown, and many celebrities have served as grand marshals of the parade. In 1948, when this picture was taken, Bing Crosby was the grand marshal.

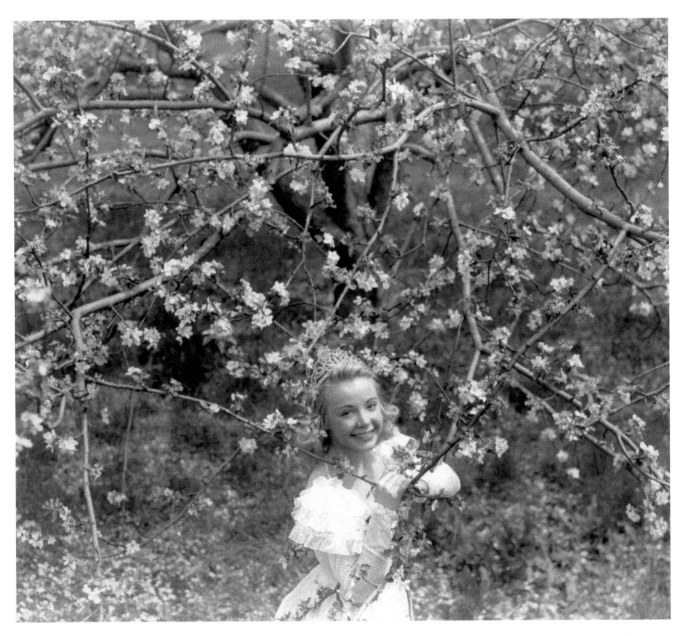

An Apple Blossom Queen, first chosen from among the young women of the Winchester area, has reigned over the Apple Blossom Festival since its inception in 1924. The 1948 queen, Gretchen Van Zandt Merrill, was photographed amid the blossoms. In recent years, young local women have been designated Miss Apple Blossom.

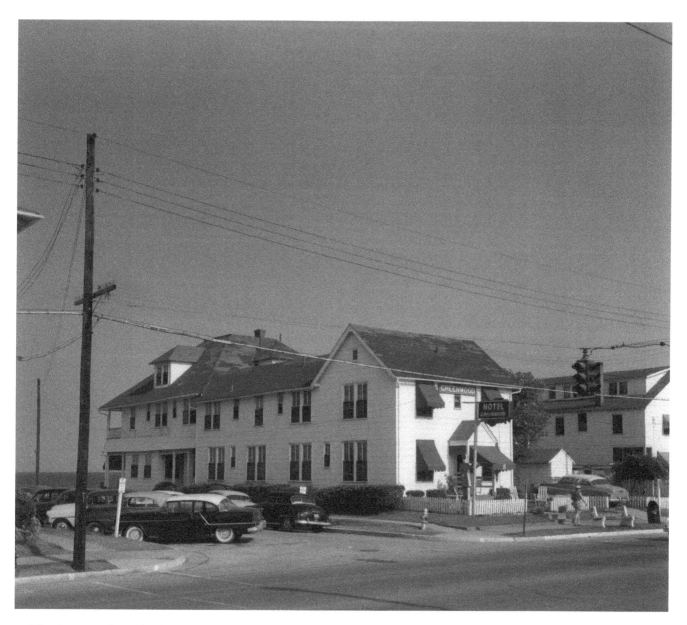

The Greenwood Hotel, photographed about 1950, stood on the Virginia Beach waterfront at Twentieth Street. A modern high-rise hotel replaced it several years ago. Until the last quarter of the twentieth century, small hostelries like the Greenwood lined the beach, but a recent overhaul of the oceanfront followed by an enormous increase in visitation has resulted in their replacement with high-rise hotels.

The Blue Ridge Parkway extends 469 miles south from the southern terminus of the Skyline Drive and Shenandoah National Park in Virginia at Rockfish Gap, to the Great Smoky Mountains of North Carolina near the Tennessee border. Construction began on September 11, 1935, as a public works program during the Great Depression. The last stretch was not completed until 1987. In this 1950 photograph, women examine wild rhododendron flowers on the Parkway south of Roanoke.

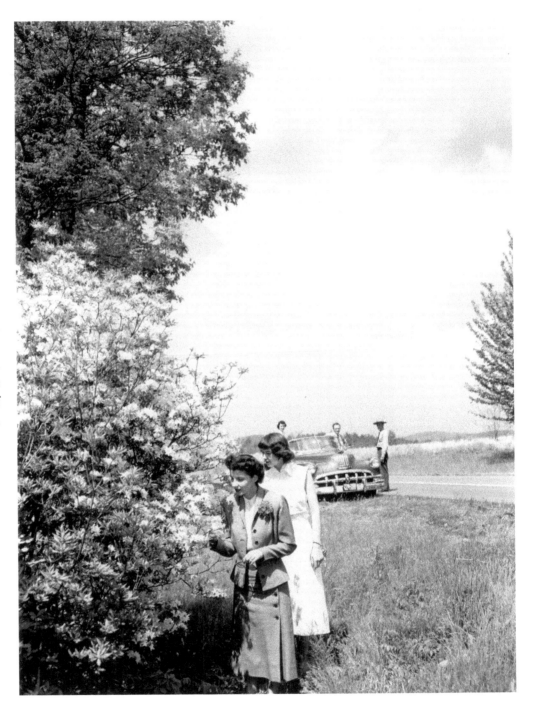

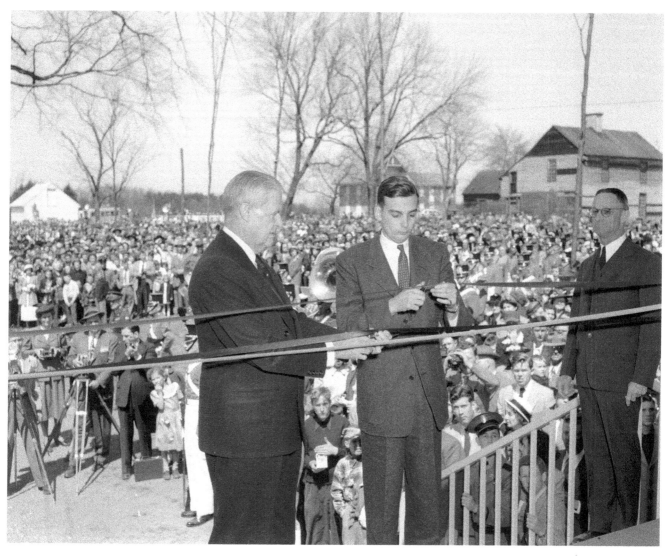

After Confederate General Robert E. Lee surrendered the Army of Northern Virginia to Lieutenant General Ulysses S. Grant on April 9, 1865, at Appomattox Court House, the little village seemed to disappear. The courthouse itself was destroyed after the county seat was moved to Appomattox Station. The McLean House, where the surrender documents were signed, was disassembled for display at the Chicago World's Fair in 1893, but the plans fell through and the building's remains sat in a heap for decades. After the National Park Service acquired the site in 1940, it used measured drawings of the house to reconstruct it beginning in 1947. Here on April 16, 1950, the McLean House was formally dedicated, with Major General Ulysses S. Grant III and Robert E. Lee IV cutting the ribbon.

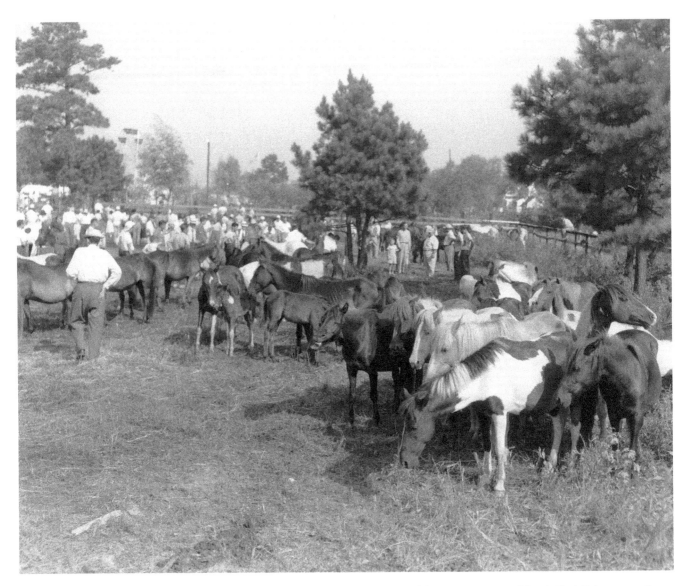

The Chincoteague Island ponies actually spend most of the year grazing on neighboring Assateague Island. Each July, some of them are herded together and then made to swim across Assateague Inlet to Chincoteague, where they are penned and sold at auction. The Chincoteague Volunteer Fire Company has owned the herd since 1947, and the proceeds from the auction go to benefit the company. Only 150 ponies at a time may live by permit on Assateague Island, which is in National Park Service custody, so the annual penning and auction serve to cull the herd to the required level. These ponies were about to be auctioned in 1951.

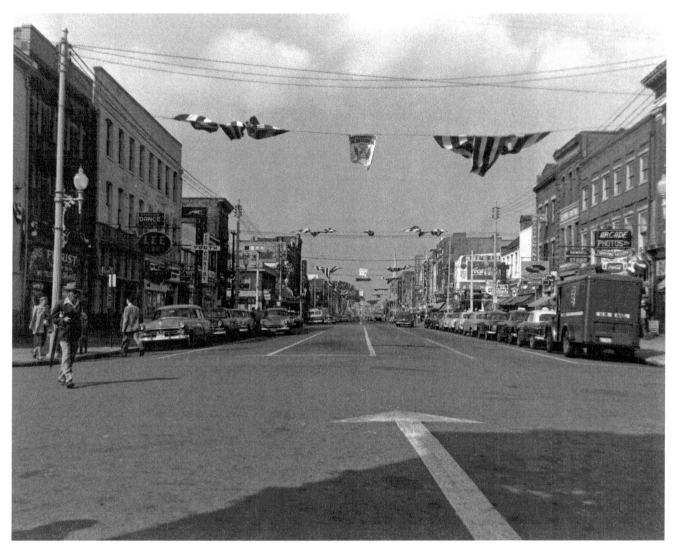

High Street was the bustling commercial heart of Portsmouth when viewed here from Water Street in 1952.

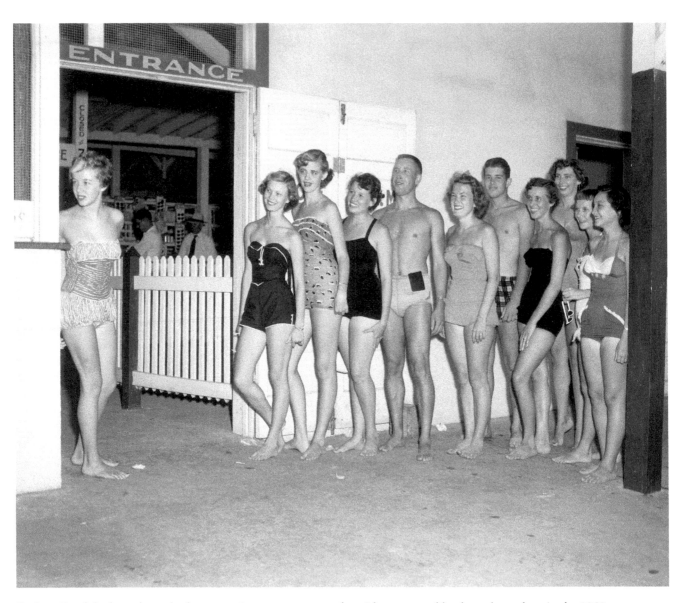

Buckroe Beach had arcades and other entertainment venues popular with teenagers, like those shown here in the 1950s.

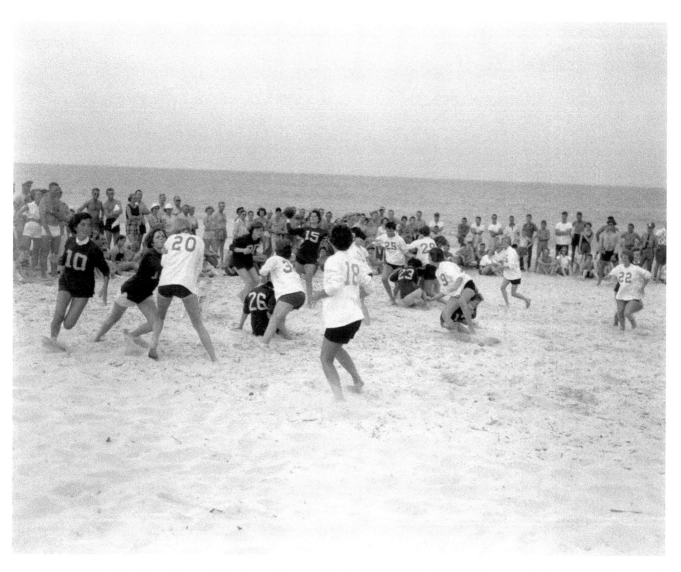

Virginia Beach has hosted many festivals over the years. In the 1950s, the Sand Festival was popular and included a women's football game.

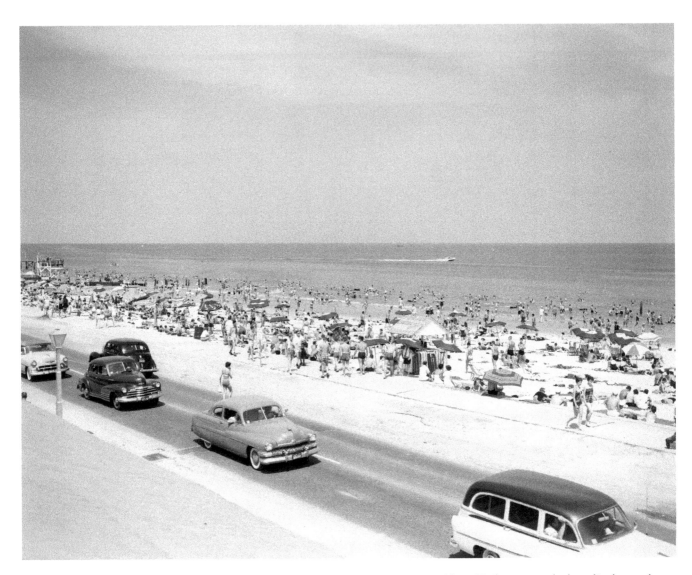

Buckroe Beach began development as a summer resort in 1883, when Mary Ann Dobbins Herbert opened a boardinghouse there, and grew rapidly after James S. Darling, of Hampton, opened the Buckroe Beach Hotel and dance pavilion on June 21, 1897. An amusement park was soon erected nearby. Other hotels followed, but by the mid twentieth century, when this picture was taken, Buckroe Beach as a resort area was declining as Virginia Beach rose in prominence.

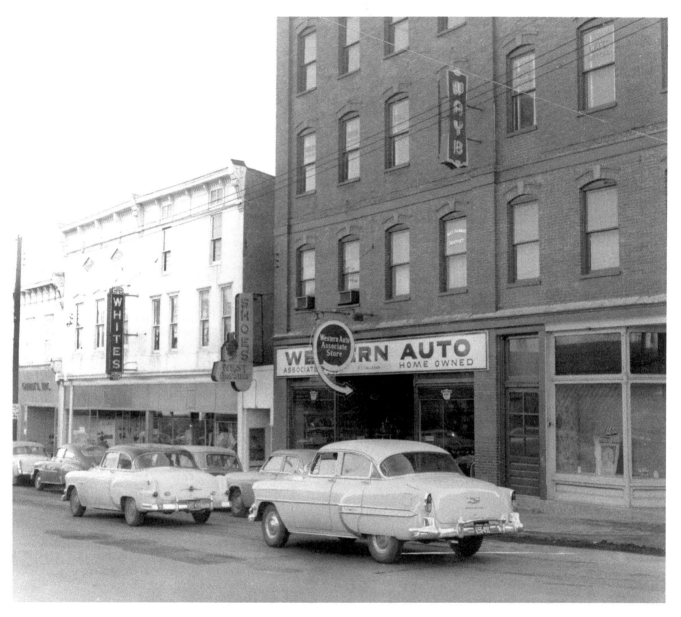

At the time of this January 1955 view of downtown Waynesboro, department stores such as White's, at left, did not have what are now called after-Christmas sales, but "white sales," in which towels, sheets, and pillowcases were marked down. The *Waynesboro News-Virginian* of January 6 carried a White's advertisement for "Pequot Combed Percale Sheets" for $2.38 each, marked down from $2.98, and 19-by-36-inch towels for 19 cents (regularly 29 cents).

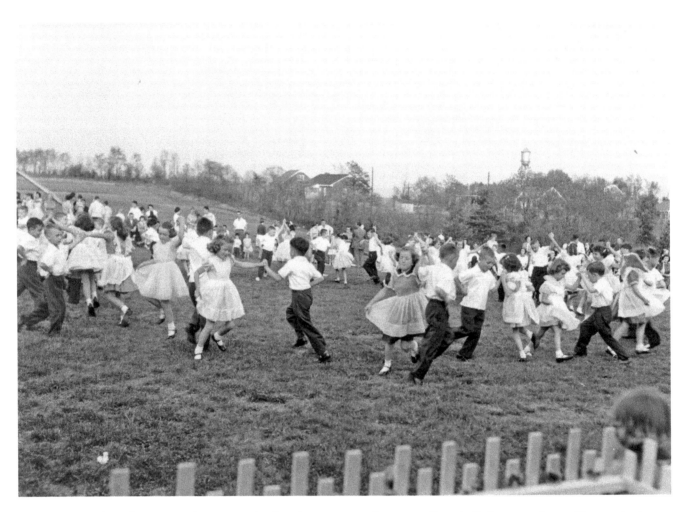

Square dancing, less often seen in elementary schools today, was a popular way to allow the little ones to burn off energy in the 1950s. These third-graders were photographed in Roanoke in May 1956.

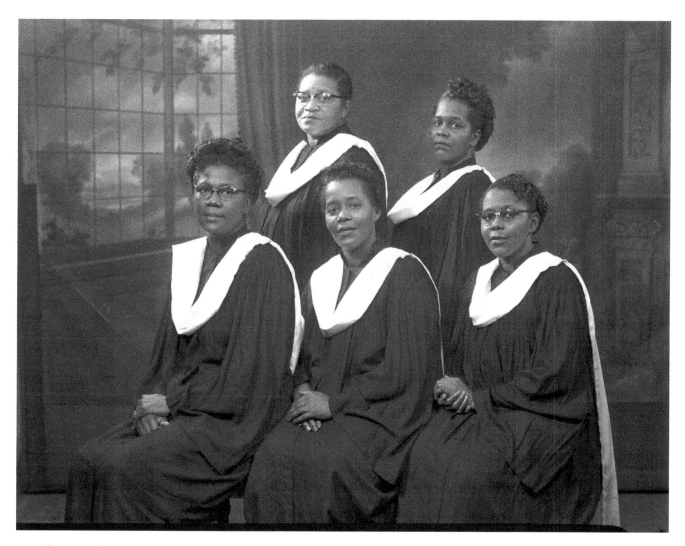

The Gospel Consolers, a Suffolk choir, was photographed on November 3, 1956. Mrs. Margaret W. Burley, one of the Gospel Consolers, was a member of East End Baptist Church and a voter registration leader who "participated in the Martin Luther King marches," according to her obituary. East End Baptist Church today conducts the Jubal Arts Center as a ministry for "instruction and enrichment in music and expressive arts."

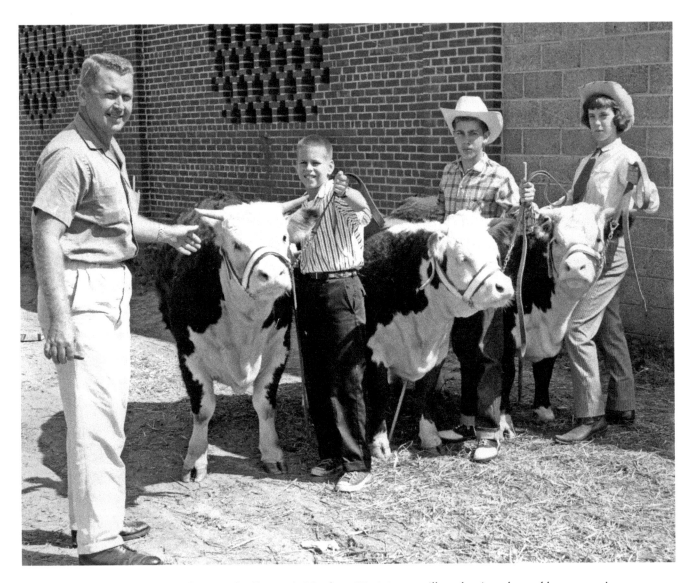

In 1959, when this picture was taken, Fairfax County in Northern Virginia was still predominantly rural but was on its way to becoming a bedroom suburb of Washington, D.C. Here three young 4-H Club members—David Homan, Clinton Kisner, and Marsh Kisner—pose with their cattle.

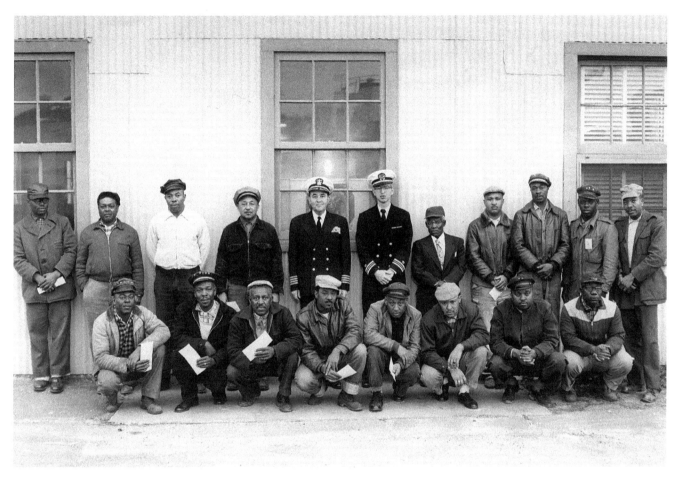

These ammunition drivers were photographed at the ammunition depot at Saint Julien's Creek near the Norfolk Naval Shipyard in Portsmouth in February 1959. The depot began operations in 1849 as an ordnance and matériel storage facility. It started assembling ammunition in 1898, and from then until 1970, the facility supplied ammunition to the fleet in addition to loading, assembling, issuing, and receiving naval gun ammunition, and conducting experimental and test loading for new ammunition. In 1969, the depot was annexed to the Naval Weapons Station at Yorktown, in 1977 to the Norfolk Naval Shipyard, and in 1996 to Naval Station Norfolk.

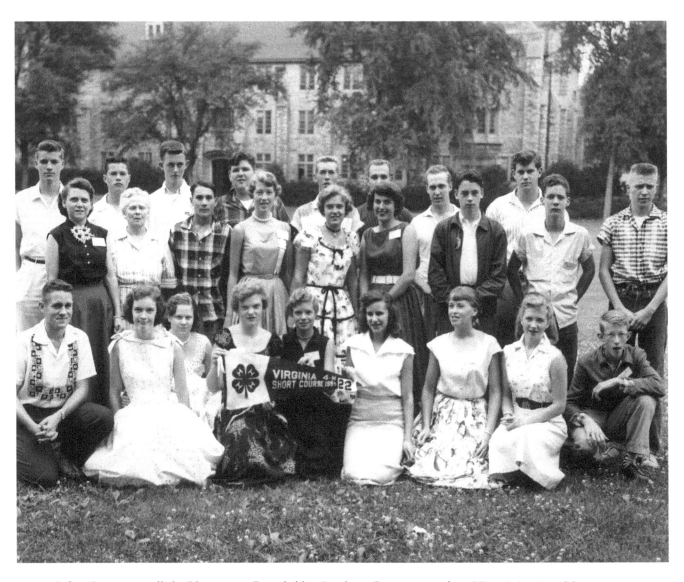

Virginia's first 4-H camp, called a "short course," was held in Loudoun County in northern Virginia in 1917. Many camps were later held on college campuses, farms, and campgrounds owned by the 4-H or by other organizations. The subjects covered included all aspects of farming and crops, animal husbandry, and canning techniques. This group of short-course attendees was photographed in Fairfax County in 1959.

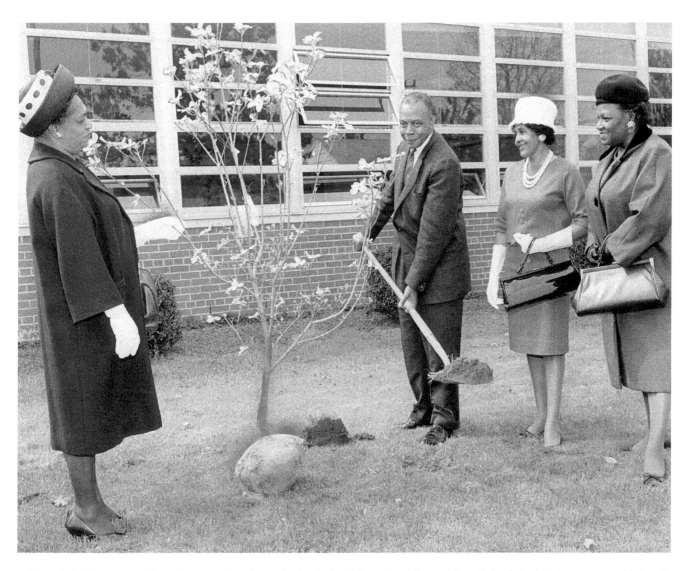

Many Virginians are avid gardeners, and at the end of each April since 1933 the Garden Club of Virginia has sponsored Historic Garden Week, when houses and gardens throughout the state are open to visitors. On April 22, 1964, members of the West Mount Hermon Garden Club donated a tree to Mount Hermon School. The principal, Ralph W. Gholson, did the planting, while Mrs. Mabel B. Allen, club president, and club members Mrs. Arlethia A. Campbell and Mrs. Eliza L. Saunders supervised.

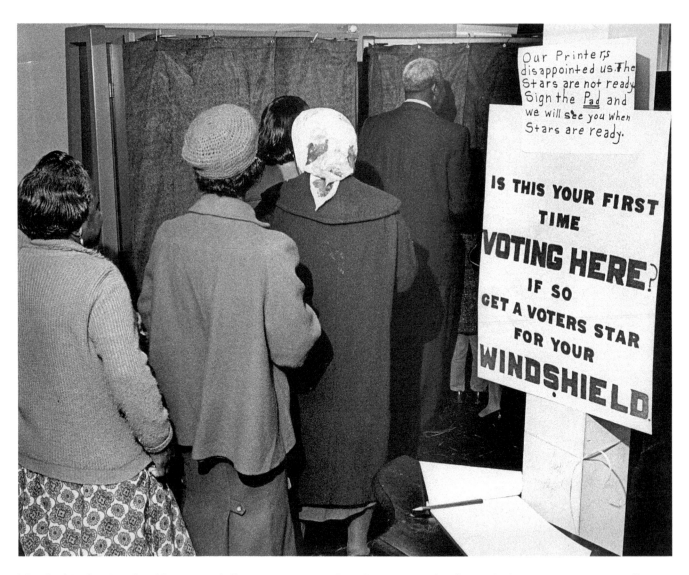

The Civil Rights Act of 1964 guaranteed all American citizens the right to vote, and millions of African Americans, especially in the South, seized the opportunity. These men and women are standing in line to vote in Portsmouth in November 1964. Each new voter was supposed to receive a gold star to display in his or her automobile, but the printer had not provided them by election day. Their future delivery, however, had been promised.

On December 1, 1966, students from I. C. Norcom High School in Portsmouth arrived at the post office with dozens of fruitcakes. They mailed the cakes to former classmates serving in the war in Vietnam.

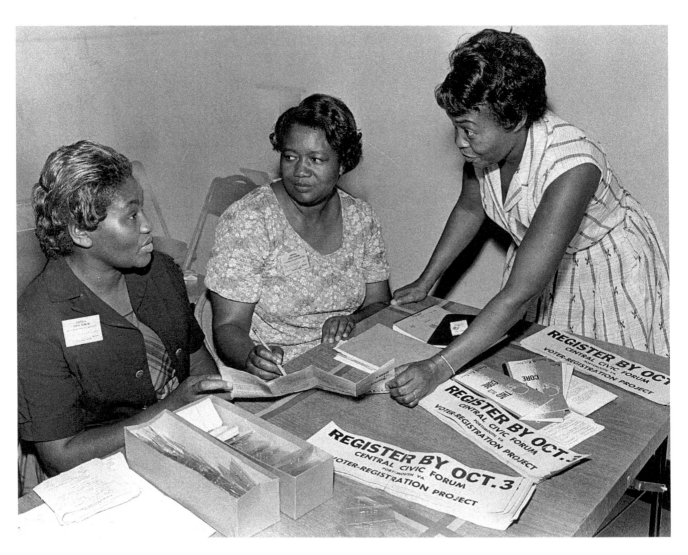

It had been only five years since the Civil Rights Act of 1964 had guaranteed all American citizens the right to vote, and had provided means of enforcing that right, when these women were photographed on September 9, 1969. They were preparing to register voters in Portsmouth for the fall elections.

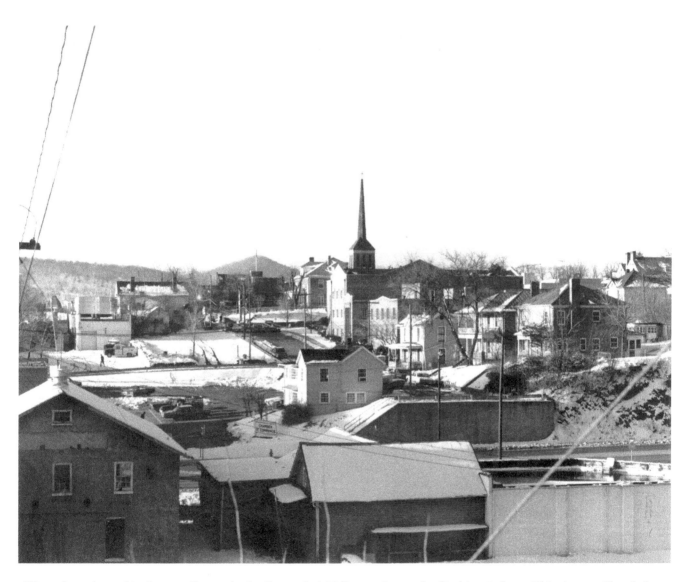

Waynesboro, located in Augusta County in the Shenandoah Valley, retains much of its historic flavor. This view up Church Street and across Broad Street from Florence Avenue shows the city as it appeared in 1969.

Designed by Portsmouth native William R. Singleton and completed in 1850, the former Norfolk City Hall seen here is one of four structures that compose the MacArthur Memorial, a tribute to and the last resting place of both General of the Army Douglas MacArthur and his widow, Jean Faircloth MacArthur. Exhibits in the complex cover the general's life and career, and one of the buildings houses a library and archives.

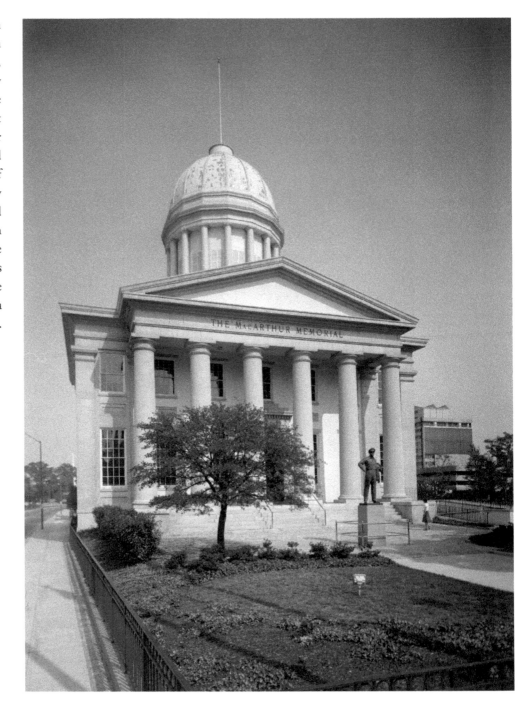

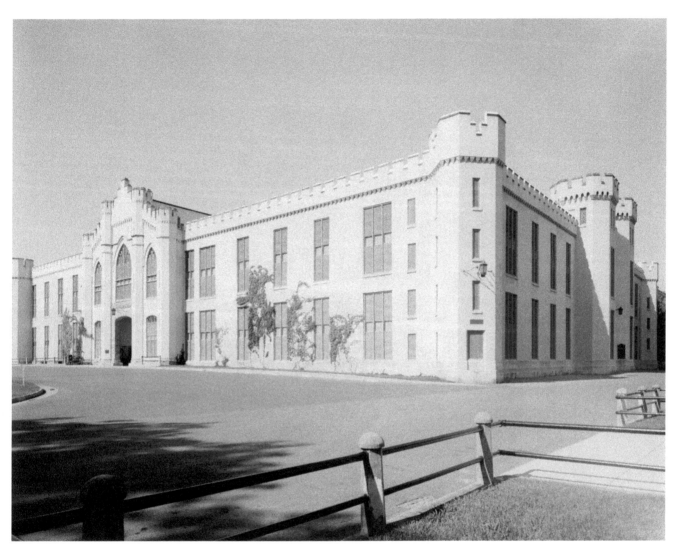

When organized in 1839, Virginia Military Institute became the nation's first state-supported military school. Between 1848 and 1861, the renowned architect Andrew Jackson Davis designed half a dozen campus buildings in the castellated Gothic Revival style, creating the prototype for other military schools and a mode of architecture called "collegiate Gothic." The Barracks, photographed in 1968, remains the focal point of the campus.

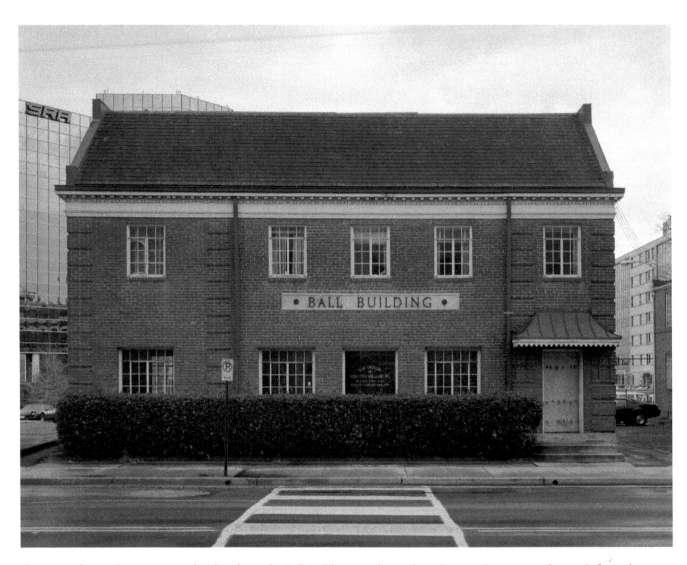

Constructed in 1940 to accommodate law firms, the Ball Building stood near the Arlington County courthouse. It formed a part of "Lawyers' Row"—a term commonly used in Virginia to describe one or more buildings that house the lawyers who practice before the county court. Virtually every county seat in the state has such an arrangement. The Ball Building was demolished in 1990.

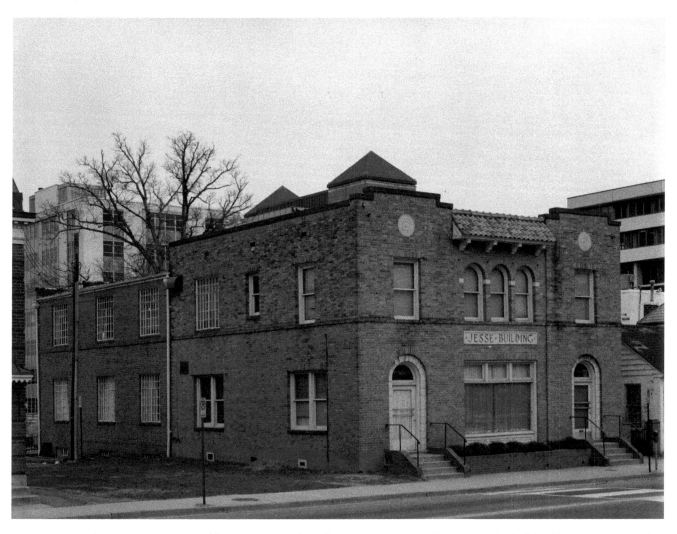

Constructed in 1927, the Jesse Building stood near the Arlington County courthouse. Like the Ball Building, it was erected to house the lawyers who practiced before the county court—an ancient arrangement in Virginia—and like the Ball, the Jesse was demolished in 1990.

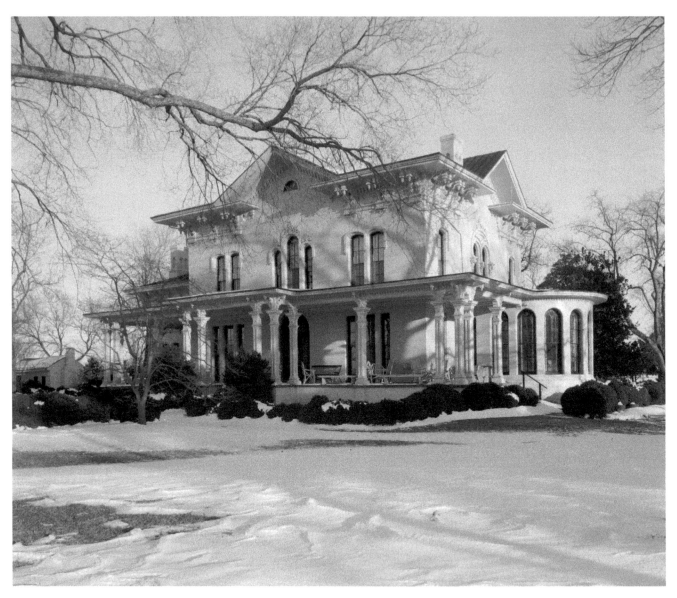

Baltimore architect Norris G. Starkweather designed this wooden house, Camden, for William C. Pratt. Completed in 1859 and located on the Rappahannock River near the town of Port Royal, the building is an outstanding example of the Italianate style. At the time of its construction, it was technologically advanced, with central heating, gas lighting, inside toilets, running water in each bedroom, and a shower bath. During the Civil War, a Union gunboat shelled the property, destroying an elaborate tower that was part of the original architectural composition.

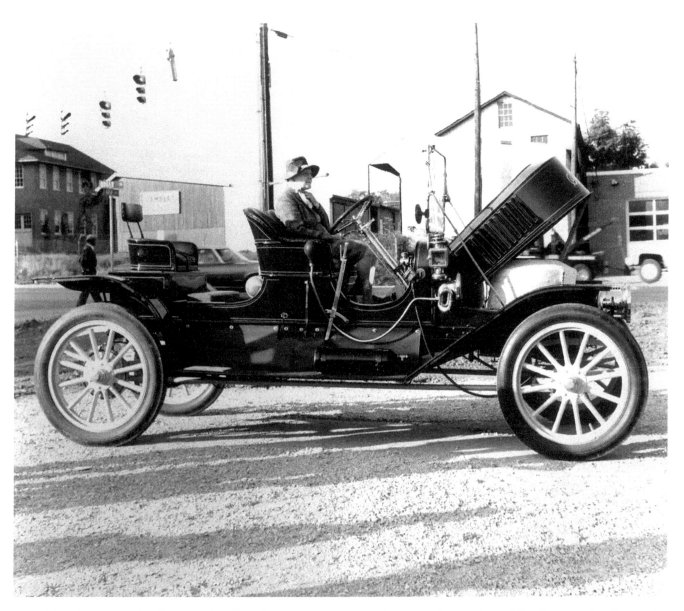

Although spring in the Shenandoah Valley is beautiful, the area is perhaps more famous for its fall foliage. Tourists flock to the valley and the Blue Ridge Mountains, and several communities put on festivals appropriate to the season. In 1973, this restored Stanley Steamer, with the owner's mother (Mrs. Ki Williams) in the front seat, was one of the attractions at Waynesboro's Fall Foliage Festival.

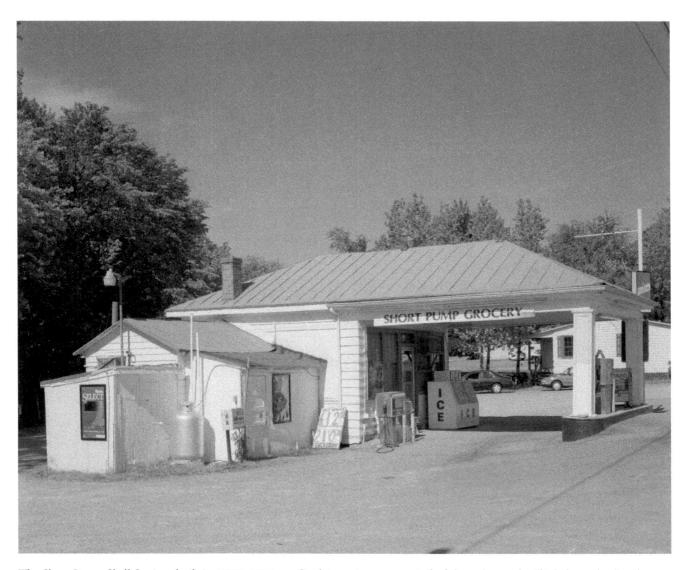

The Short Pump Shell Station, built in 1938–1939 as a Sinclair station, was typical of the era's popular "little bungalow" style of filling-station design. Once common in small towns and rural areas, stations such as this one are increasingly subject to abandonment or demolition. The farm community of Short Pump, located west of Richmond, has been virtually absorbed into the city's western suburbs since this picture was taken a few decades ago. Happily, in 1996 this service station was moved with another building farther west to Goochland County and restored as part of a permanent "Field Days of the Past" exhibition there.

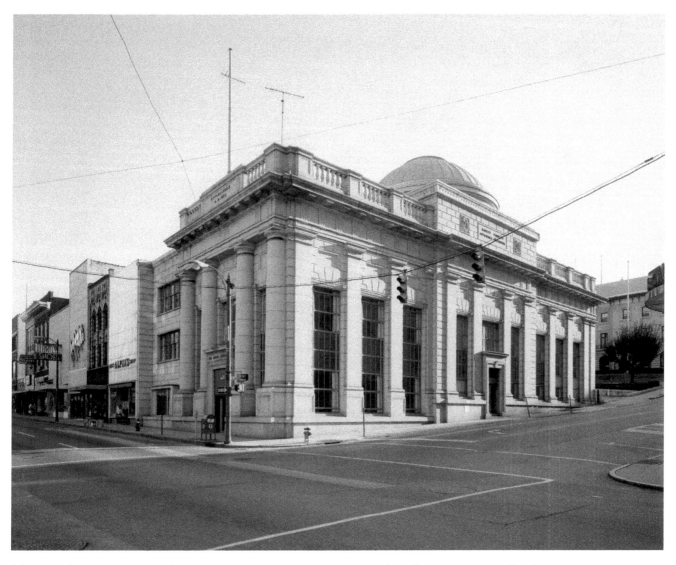

The Lynchburg National Bank building, located at the corner of Main and Ninth streets, was completed in 1915–1916. Seen here in the 1970s, the impressive building still stands.

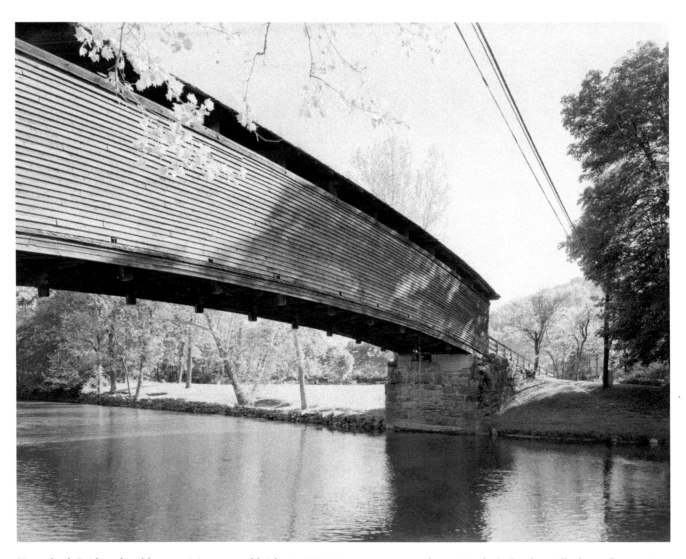

Humpback Bridge, the oldest surviving covered bridge in Virginia, was constructed over Dunlap's Creek in Alleghany County in 1857. Seen here about 1970, it is also the nation's only extant curved-span covered bridge. Nineteenth-century wooden bridges were covered not to provide romantic buggy rides but to protect the superstructure from the elements. The bridge was part of the James River and Kanawha Turnpike, an antebellum highway from Virginia into what is today West Virginia.

Notes on the Photographs

These notes, listed by page number, attempt to include all aspects known of the photographs. Each of the photographs is identified by the page number, a title or description, photographer and collection, archive, and call or box number when applicable. Although every attempt was made to collect all data, in some cases complete data may have been unavailable due to the age and condition of some of the photographs and records.

60 CONFEDERATE REUNION
Courtesy of The Library of Virginia
VCC-N-images-003115-015

61 HUGGINS HOUSE
Library of Congress
LC-USZ62-120469

62 OLD SLUICE MILL
Library of Congress
LC-USZ62-6744

63 GARDEN ARCADE, MIRADOR
Library of Congress
LC-USZ62-130389

64 VIRGINIA BEACH
Courtesy of The Library of Virginia
VCC-N-images-003316-004

65 BUSINESS SECTION IN ROANOKE
Library of Congress
pan 6a15781

66 MEMBERS OF THE BOGTROTTERS BAND
Library of Congress
LC-DIG-ppmsca-00401

67 HOTEL MONROE
Courtesy of The Library of Virginia
VDLP-OLT-images-1023029

68 SUNSET VIEW
Courtesy of The Library of Virginia
WF-07-09-024

69 GREAT FALLS OF THE POTOMAC
Courtesy of The Library of Virginia
WF-08-03-024

70 VIRGINIA STATE CAPITOL
Courtesy of The Library of Virginia
WF-05-07-001

71 ROANOKE VALLEY
Courtesy of The Library of Virginia
WF-08-02-006

72 POCAHONTAS EXHIBITION MINE IN TAZEWELL COUNTY
Courtesy of The Library of Virginia
WF-01.10-001

73 HAY FIELD
Library of Congress
8c13876u

74 THE ESTES MILL
Library of Congress
165189pu

75 VIRGINIA STATE LIBRARY AND SUPREME COURT BUILDING
Library of Congress
LC-DIG-gsc-5a07386

76 NORFOLK NAVAL AIR BASE
Courtesy of The Library of Virginia
VCC-N-images-008858-000

77 THE OLD COURTHOUSE
Library of Congress
LC-USQ33-026186-C

78 MARGARET HUNTER'S MILLINERY SHOP
Library of Congress
LC-USW33-026178-C

79 MEMORIAL HOSPITAL IN SUFFOLK
Courtesy of The Library of Virginia
VA-Suffolk-hospitals

80 EVICTION OF FAMILY IN CAROLINE COUNTY
Library of Congress
17183u

81 CHRISTMAS MORNING FOR THE TROOPS
Courtesy of The Library of Virginia
VTLS-SC-35-005

82 B-17 BOMBER ON LANGLEY FIELD
Library of Congress
1a35090u

83 NAVAL SHIPYARD WORKERS WAITING FOR BUS
Courtesy of The Library of Virginia
VDLP-OLT-images-1034007

84 WAR DOGS
Courtesy of The Library of Virginia
VTLS-SC-27-092

85 OYSTER ROAST AT CAMP PATRICK HENRY
Courtesy of The Library of Virginia
VTLS-SC-29-012

86 CAMP PATRICK HENRY'S MILK BAR
Library of Congress
VTLS-SC-28-042

87 USS J. W. McANDREW
Courtesy of The Library of Virginia
VTLS-SC-31-009

88 ARMISTICE DAY PARADE
Courtesy of The Library of Virginia
VTLS-SC-33-047

90 VIRGINIA BEACH BOARDWALK
Courtesy of The Library of Virginia
VCC-N-images-008808-000

91 RIDING TOURNAMENT
Courtesy of The Library of Virginia
VCC-N-Images-010175-000

92 DANVILLE STREET SCENE
Courtesy of The Library of Virginia
VCC-N-images-010008-000

93 IRWIN'S PHARMACY
Courtesy of The Library of Virginia
VDLP-OLT-images-1015001

94 SKYLINE DRIVE
Courtesy of The Library of Virginia
VCC-N-images-011276-000

95 MONTICELLO
Courtesy of The Library of Virginia
VCC-N-images-011327-000

96 SAILBOATS ON LINKHORN BAY
Courtesy of The Library of Virginia
VCC-N-images-011445-000

97 DEEP RUN HUNT RACES
Courtesy of The Library of Virginia
VCC-N-images-011485-000

98 **MERCHANTS SQUARE**
Courtesy of The Library of Virginia
VCC-N-images-011133-000

99 **THE RALEIGH TAVERN**
Courtesy of The Library of Virginia
VCC-N-images-011138-000

100 **UNIVERSITY OF VIRGINIA ROTUNDA**
Courtesy of The Library of Virginia
VCC-N-images-011352-000

101 **WINCHESTER APPLE BLOSSOM FESTIVAL**
Courtesy of The Library of Virginia
VCC-N-011177-000

102 **APPLE BLOSSOM QUEEN**
Courtesy of The Library of Virginia
VCC-N-images-011156-000

103 **THE GREENWOOD HOTEL**
Courtesy of The Library of Virginia
VCC-N-images-01743-000

104 **BLUE RIDGE PARKWAY**
Courtesy of The Library of Virginia
VCC-N-images-013000-000

105 **MCLEAN HOUSE DEDICATION**
Courtesy of The Library of Virginia
VCC-N-images-013470-000

106 **CHINCOTEAGUE ISLAND PONIES**
Courtesy of The Library of Virginia
VCC-N-images-013978-000

107 **HIGH STREET, PORTSMOUTH**
Courtesy of The Library of Virginia
VDLP-OLT-images-1022025

108 **TEENAGERS AT BUCKROE BEACH**
Courtesy of The Library of Virginia
VCC-N-images-016196-000

109 **VIRGINIA BEACH SAND FESTIVAL**
Courtesy of The Library of Virginia
VCC-N-images-016451-000

110 **BUCKROE BEACH**
Courtesy of The Library of Virginia
VCC-N-images-016194-000

111 **DOWNTOWN WAYNESBORO**
Courtesy of The Waynesboro Public Library;
Courtesy of The Library of Virginia
VDLP-Waynesboro-images-0699

112 **CHILDREN SQUARE-DANCING**
Courtesy of The Library of Virginia
VDLP-Roanoke-images-221

113 **THE GOSPEL CONSOLERS**
Courtesy of The Library of Virginia
VDLP-Suffolk-images-negatives-ng0016b

114 **4-H MEMBERS**
Courtesy of The Library of Virginia
VDLP-Fairfax-extension_service-images-fxco_ex_351

115 **AMMUNITION DRIVERS**
Courtesy of The Library of Virginia
VDLP-POR-ROD-images-01243

116 **ATTENDEES OF VIRGINIA 4-H SHORT COURSE**
Courtesy of The Library of Virginia
VDLP-Fairfax-extension_service-images-fxco_ex_347

117 **TREE PLANTING**
Courtesy of The Library of Virginia
VDLP-POR-ROD-images-00754

118 **IN LINE TO VOTE**
Courtesy of The Library of Virginia
VDLP-POR-ROD-images-00438

119 **FRUITCAKES FOR THE TROOPS IN VIETNAM**
Courtesy of The Library of Virginia
VDLP-POR-ROD-00927

120 **VOTER-REGISTRATION PROJECT**
Courtesy of The Library of Virginia
VDLP-POR-ROD-images-01236

121 **WAYNESBORO**
Courtesy of The Waynesboro Public Library;
Courtesy of The Library of Virginia
VDLP-Waynesboro-images-0848

122 **THE MACARTHUR MEMORIAL**
Library of Congress
163967pu

123 **THE BARRACKS, VIRGINIA MILITARY INSTITUTE**
Library of Congress
165423pu

124 **BALL BUILDING**
Library of Congress
164688pu

125 **JESSE BUILDING**
Library of Congress
164730pu

126 **HOUSE DESIGNED BY NORRIS G. STARKWEATHER**
Library of Congress
160282pu

127 **RESTORED STANLEY STEAMER**
Courtesy of The Waynesboro Public Library;
Courtesy of The Library of Virginia
VDLP-Waynesboro-images-0141